IMAGES of America
LOST GAS STATIONS OF SAN MATEO COUNTY

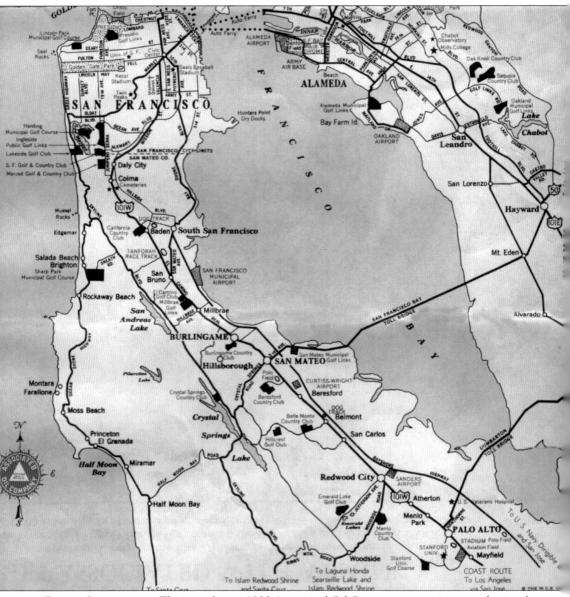

DRIVER CONVENIENCE. This page from a 1933 Associated Oil Company gas station map depicts the major roads of the southern San Francisco Bay. San Mateo County stretches from just below the Hunters Point Dry Docks south to the bottom of the map. Notice that auto ferries are providing transportation across the bay, as both the San Francisco–Oakland Bay Bridge and the Golden Gate Bridge were still three and four years in the future, respectively. (Authors' collection.)

ON THE COVER: SERVICE IN ACTION. An attendant provides full service to the driver of this 1962 Ford Thunderbird by filling the gas tank, checking oil and tire pressure, and washing windows at the Shell gas station on Twentieth Avenue and El Camino Real in San Mateo in this 1962 photograph. Notice the Ford Falcon on the rack in the service bay to the rear. (San Mateo County Historical Association, Norton Pearl Collection, 2015.1.03758.2.)

IMAGES
of America

LOST GAS STATIONS OF SAN MATEO COUNTY

Bruce C. Cumming
and Nicholas A. Veronico

ARCADIA
PUBLISHING

Copyright © 2025 by Bruce C. Cumming and Nicholas A. Veronico
ISBN 978-1-4671-6179-4

Published by Arcadia Publishing
Charleston, South Carolina

Printed in the United States of America

Library of Congress Control Number: 2024937834

For all general information, please contact Arcadia Publishing:
Telephone 843-853-2070
Fax 843-853-0044
E-mail sales@arcadiapublishing.com

Visit us on the Internet at www.arcadiapublishing.com

For Jeff and Chris Nielsen, the last of the full-service station owners

In memory of the late Joe C. Bradshaw

CONTENTS

Acknowledgments	6
Introduction	7
1. North County: Brisbane, Burlingame, Colma, Daly City, Millbrae, San Bruno, and South San Francisco	11
2. Central County: Belmont, Foster City, Farallone City, Half Moon Bay, Montara, Pacifica, and San Mateo	43
3. South County: East Palo Alto, La Honda, Menlo Park, Portola Valley, Redwood City, San Carlos, and Woodside	73
4. Gone but Not Forgotten: Changing Times, Changing Technology	121

Acknowledgments

The authors wish to thank the following individuals and groups for their assistance in preparing this book: George Andrews, Ed Archer, Jim Boyden, Arthur Babitz, Joe Brennan, Carol Bria, Roger Cain, Dave Capps, Caroline Cheung, Lydia Cooper, Robin Cunha, Tom Dawdy, Bob Dougherty, Mary Ergas, Ray Gier, Pat Kremer, Martha Lancestremere, Paul Lechich, Jim Lewis, Darryl Lindsay, Jim Lipman, Suzanne Mau, Janet McGovern, Don McGrath, Karl Mittelstadt, Dave Nannini, Chris Nielsen, Jeff Nielsen, Dave Olson, Curtis Parisi, Debra Peterson, Jennifer Pfaff, Morganne Pockels, Perky Ramroth, Bob Reed, Marilyn Repp, Richard Rocchetta, Dennis Stopper, Jean Thivierge, Tim Tolan, Dean Treft, Paul Vaughn, Gary Vielbaum, Mark Weinberger, Rob and Kathy (Zanone) Wolf, Deborah Wong, Marian Wydo, and Caroline Yee.

Thanks also goes to the Belmont Historical Society; Brisbane History Museum and Archive; Burlingame Historical Society; Colma Historical Association; Daly City History Guild; Foster City Historical Society; Half Moon Bay History Association; Hood River County History Museum; Menlo Park Historical Association; Millbrae Historical Society; Pacifica Historical Society; Portola Valley Historic Resources Committee; Local History Room, Redwood City Public Library; San Bruno History Collection; San Carlos Museum of History; San Mateo County Historical Association; South San Francisco Historical Society; and Town of Woodside Archives.

Photograph credit abbreviations:

BHS	Belmont Historical Society
DCHGMA	Daly City History Guild Museum and Archive
MPHA	Menlo Park Historical Association
LHR-RWCPL	Local History Room, Redwood City Public Library
PHS	Pacifica Historical Society
SCMH	San Carlos Museum of History
SMCHA	San Mateo County Historical Association
WCM	Woodside Community Museum

INTRODUCTION

The modern automobile of the 21st century traces its roots back some 130 years to the inventions of the late 19th century. Such pioneers as Karl Benz, Charles Duryea, Henry Ford, R.E. Olds, James and William Packard, Alexander Winton, and others who built early versions of autos powered by internal combustion engines are often credited with putting America on the road. The vehicles of today that we take for granted have a long and complex history.

The early development of the automobile coincides with the development of support services to keep them roadworthy. Products to power and lubricate engines of the "horseless carriages" included, most notably, gasoline and oil. In the very early days, the liquid to power engines was supplied by gasoline, a volatile by-product of refining kerosene that had long been used to light stoves and lamps. Moreover, oil was mainly used as a waterproofing product or to pave dirt roads. Once it was determined that oil could be used to lubricate vehicles and refined into gasoline, it became necessary to develop ways to dispense the product.

Before filling stations existed, early auto owners obtained fuel dispensed from barrels into buckets inside local general stores, often using hand pumps invented by S.F. Bowser in 1895. Once the owner obtained the fuel from the store, he or she would simply pour the gas through a funnel into the car's tank—a very dangerous practice indeed. After some explosions and fires, gasoline barrels were moved outside. Blacksmith shops or repair garages provided outdoor wooden storage sheds that contained gasoline and buckets.

In 1898, after studying Bowser's hand pump used mostly to supply kerosene, John J. Tokheim devised a simpler and safer way to dispense gasoline by placing a tank underground outside with Bowser's "kerosene" pump installed directly above. It is said that this was the birth of the gas pump. By 1905, Bowser had further refined methods of dispensing gasoline when he invented the self-measuring gas storage pump to be used with a storage tank at the curb. Later, he added a hose and nozzle to make it more convenient and safer for motorists to fill up. From these early pumps, consumers sought to ensure they were receiving the amount of gasoline they were paying for, which resulted in the "visible" pump. Visible pumps had a clear tank with measuring markers on top where an attendant could pump a specific amount of fuel into the tank, which the customer could see and verify, that was then gravity fed into the car's tank through a nozzle and hose. Visible pumps were replaced by computing pumps that would calculate the amount of fuel dispensed as it passed from the pump into the gas tank.

The filling stations of San Mateo County evolved in parallel with the rest of the nation. The county was mostly rural. Roads were poor; dusty in summer, muddy in winter. Autos were expensive and scarce. Those who could afford an automobile had difficulty obtaining gasoline for their machines so they turned to hardware stores, drugstores, and blacksmith shops that maintained a supply of the volatile fuel. As cars became more common, owners got their fuel at curbside pumps. When curbside filling stations became congested with cars lining up in the street, gas stations soon began to move away from streets onto property owned by petroleum companies. There are

several claims that the first gas station was built by the Standard Oil Co. in 1907 in Seattle, Washington. Others argue that an earlier dedicated station opened in 1905 in St. Louis, Missouri. Most historians agree, however, that the first "real" drive-in gas station was opened in 1913 by the Gulf Refining Co. in Pittsburgh, Pennsylvania. Within several years, many of the major oil companies were operating their own filling stations.

It is unknown where the first true gas station in San Mateo County was built, but it is likely that the station was established along a busy roadway or within the city limits of one of the earlier towns of the county like Brisbane, Burlingame, Menlo Park, Redwood City, San Mateo, or South San Francisco. What is known is that as San Mateo County's population grew rapidly during the 20th century and automobiles became more popular, gas stations appeared throughout the county in great numbers. Today, it is hard to believe that at one time, every major intersection along boulevards like El Camino Real or Bayshore Highway contained three or four stations, one on each corner. The small city of San Carlos, for example, which stretches two miles along El Camino Real from the Belmont to the Redwood City border, once had 23 service stations. Now there are but five.

In addition to fuel and oil, service stations were just that—a place to get one's car serviced. Minor services like windshield wipers and adding oil could be done at the pumps. Additionally, most stations had two or more service bays where oil and tires were changed and trained mechanics diagnosed and repaired nearly anything that ailed a motor vehicle. When a manufacturer's maintenance warranty expired, most motorists would then take their cars to the corner gas station for needed repairs. The station's location was often more convenient than taking the car to the dealer, and appointments were usually not necessary. In addition, service stations had smaller operating overhead so their repair prices were much lower than the dealer's.

Of note, in the early days, many stations sold various brands of gasoline at differing grades. Unlike today's Chevron, Mobil, and Union 76 stations, early gasoline retailers might sell Chevron/ Standard in one pump, Gilmore in another, and Shell products in a third. Corporate alignment of brands, company and franchise retailers, and brand advertising did not come on the corporate scene until the late 1940s.

In the highly competitive gasoline market, special promotions and loyalty rewards, like S&H Green Stamps and Blue Chip Stamps, helped retailers build loyal, repeat customers. Stamps were dispensed in varying amounts depending on how much gas was purchased. The stamps were pasted into booklets and were redeemable for merchandise ranging from home appliances to furniture. In 1968 and 1969, Shell stations promoted the company's "Mr. President Coin Game." This was one of the first and extremely successful collect-and-win games with cash prizes ranging from $1 to $5,000. Motorists would fill their tanks and receive an aluminum coin that was inserted into a game board. When a section was filled, the game board was redeemed for the prize. Notice the number of stations with signage promoting loyalty programs today.

Lost Gas Stations of San Mateo County shows the gas stations of a bygone era in one California county from Daly City to East Palo Alto. This photographic tour depicts stations' primitive beginnings when they were simply a place to fill your tank, to the peak of their popularity in the 1960s when they provided real service to customers. Unfortunately, the days of "fill 'er up," checking your oil and tires, and cleaning your windshield are gone. Gone too are the snazzy attendants who knew you by name, knew your car, did repairs, sold tires, and offered free maps and loyalty rewards.

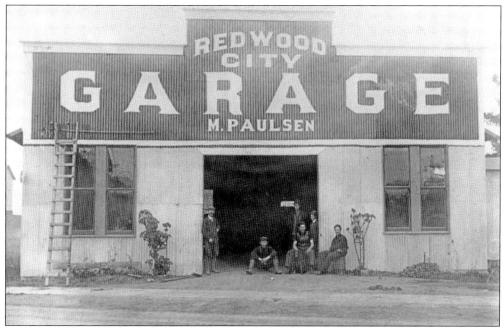

REDWOOD CITY, EARLY DAYS. Miller Paulsen's business began as Redwood Cyclery and then the name was changed to R.C. Garage and R.C. Cyclery; however, everyone in town simply knew the business as "Paulsen's." Miller's brother Jacob was the shop foreman and mechanic, and he brought the first motorcycle to Redwood City in 1900. (LHR-RWCPL.)

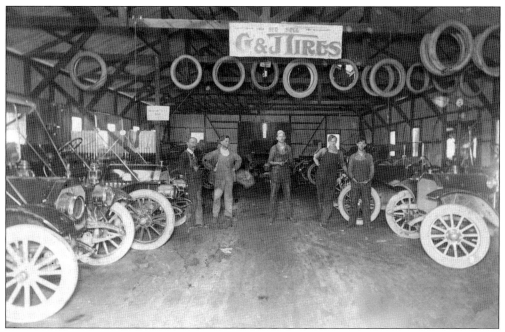

REDWOOD CITY. Inside Paulsen's, Jacob Paulsen (left), Miller's brother, and four mechanics seem to have plenty of Brass Era automobiles to work on in this photograph taken around 1910. Miller Paulsen sold the business in 1912. (LHR-RWCPL.)

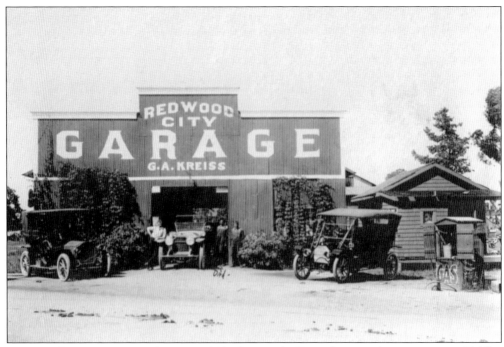

GETTING GAS IN REDWOOD CITY. In 1912, George A. Kreiss became the proprietor of Miller Paulsen's auto repair business and ran this garage for the next five years on Mound Street (now Main Street). Notice there are no gas pumps. Gasoline was stored in cans inside small wooden structures marked "gas." The vehicles shown in this image are, from left to right, a 1909 Packard Model 18, a 1912 Simplex with electric headlight conversion, and a 1910 Chalmers Model 30. (LHR-RWCPL.)

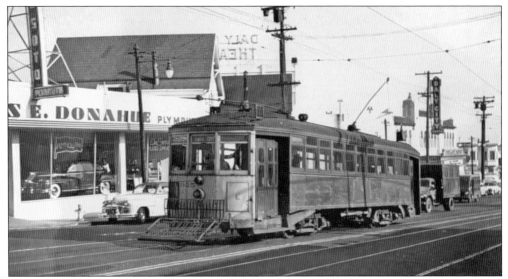

DALY CITY. Cars were not sold between 1942 and 1945, and demand for consumer goods following World War II saw a huge boom in automobile sales. New cars, coupled with population expansion to the suburbs, turned riders into drivers. Here, San Francisco Trolley car 955, running on the No. 14 line, passes the James E. Donohue DeSoto/Plymouth dealership at 6232 Mission Street in 1948. The following year, the trolley cars were replaced by buses. (Colma Historical Society.)

One

NORTH COUNTY
BRISBANE, BURLINGAME, COLMA, DALY CITY, MILLBRAE, SAN BRUNO, AND SOUTH SAN FRANCISCO

Seven miles south of downtown San Francisco lies San Mateo County and the North County cities of Brisbane and Daly City. Farther south is the town of Colma and the cities of South San Francisco, San Bruno, and Millbrae. San Mateo County was largely a rural area with few cities, primitive roads, and sparse traffic. At the time, motorists heading south on unpaved roads in the early 20th century had few choices for fueling their horseless carriages.

In 1910, the population of the entire county was only 26,500 residents, and few owned automobiles. Those who did own cars filled their tanks at hardware stores, pharmacies, or blacksmith shops. Moreover, San Francisco Peninsula residents traveled by train or electric trolley cars so there was little incentive to open filling stations.

The introduction of the inexpensive Model T Ford in 1908 took a few years to be adopted by the traveling public. Some of the earliest stations in the North County were established along Mission Street and to the south along El Camino Real in Colma and Daly City.

With the increase in auto traffic, San Mateo County and the state began to improve some roads, beginning with the paving of a five-mile stretch of El Camino Real from San Bruno to Burlingame in 1912; the first highway in the state of California to be paved.

In the 1920s, as automobile ownership increased and additional roads were improved, gas stations appeared rapidly on boulevards and downtown streets throughout the North County. When the Bayshore Highway was completed from San Francisco to San Mateo in 1929, more stations were built along the modern four-lane roadway at key intersections in Brisbane, South San Francisco, San Bruno, and Millbrae.

These new gas stations were welcomed by traveling motorists. They provided abundant gasoline dispensed from modern pumps at fair prices, plus courteous service, clean restrooms, free road maps, and tire and engine repairs. These new facilities were a far cry from the early filling stations where no service was provided and gasoline was obtained in buckets from retail stores.

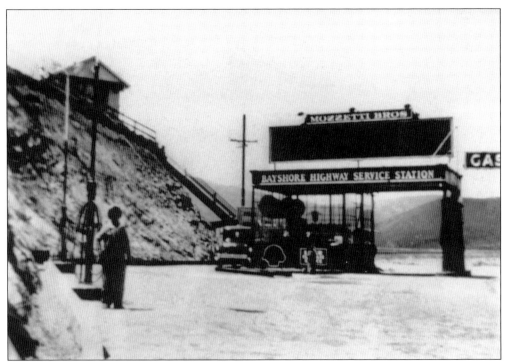

BRISBANE, FIRST STATION. Motorists driving south from San Francisco had their first opportunity to fill up at the Mozzetti Brothers' station on Bayshore Highway in Brisbane. The brothers'—Charles, Joseph, and Steve—main business was running a large dairy farm in town. This was followed in 1920, by a service station, which grew to add a store, restaurant, motel, and "auto camp" a decade later. (Authors' collection.)

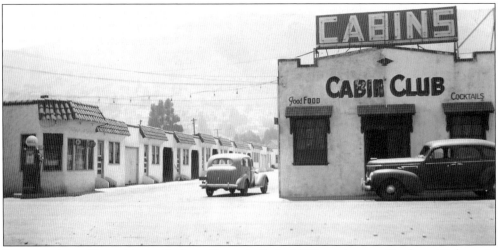

BRISBANE AUTO CAMP. Mozzetti's Auto Court, built in 1929 on the new Bayshore Highway in Brisbane, was a convenient stop for weary motorists headed south from San Francisco. This 1940s view of the court and adjacent Cabin Club was convenient for customers who could rent a room for a moderate price, enjoy a cocktail and delicious Italian meal, and fill their tank with Shell gasoline all at one location. (Brisbane Library History Collection.)

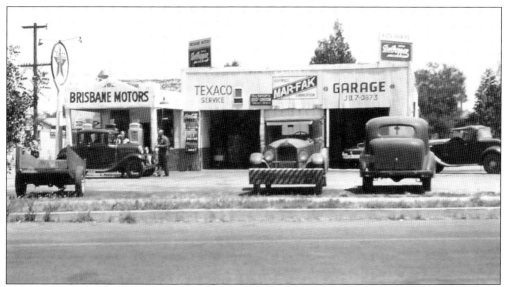

BRISBANE TEXACO. Brisbane Motors and Garage, a Texaco dealer, was located on the corner of Visitacion and San Bruno Avenues. Business looks good in this 1940s view with a Model A Ford filling up at the Wayne Model 70 pumps and a 1936 Chevrolet and 1932 Ford Roadster in for repairs. The Brisbane Motors tow truck with a wooden bumper is set up to push vehicles suffering breakdowns in town or on the highway. (Brisbane Library History Collection.)

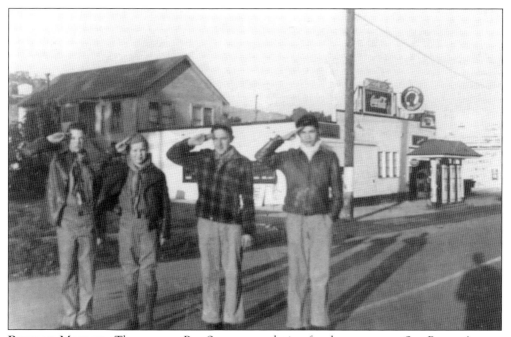

BRISBANE MOHAWK. These young Boy Scouts are saluting for the camera on San Bruno Avenue sometime in the 1940s, just up the street from Chuck's Mohawk station seen in the background. From left to right are Bob Tann, unidentified, Bob High, and Norman Brown. This location is the current site of the Brisbane Teen Center. (Brisbane Library History Collection.)

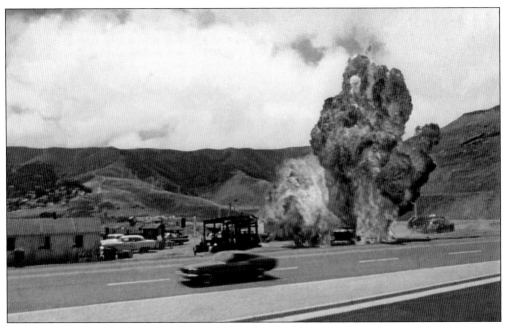

BRISBANE AND BULLITT. One of the best movie car chases on film appears in the 1968 Steve McQueen movie *Bullitt*. Fans will recognize this shot showing the results of the bad guys in the black Charger crashing into the gas station's pumps during the film's chase scene. The station was located at Guadalupe Canyon Parkway and North Hill Drive. Today, the location is a two-story office building. (Warner Brothers.)

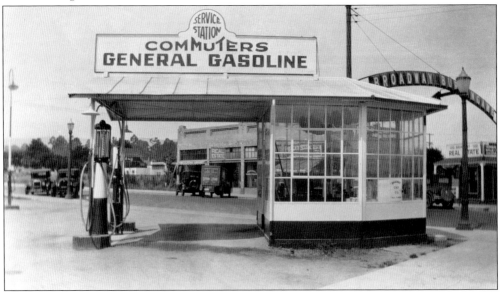

BURLINGAME EARLY STATION. Commuters General Gasoline was located across the street from the Broadway-Burlingame train depot at California Drive. The station was owned by Allyn, Malcom, and Ralph Button in 1930, when this photograph was taken. It was next to the Broadway Burlingame Arch, which originally was at Howard Avenue and El Camino Real to advertise Pacific City, an early Coyote Point amusement park dubbed the "Coney Island of the West." (History Museum of Hood River County.)

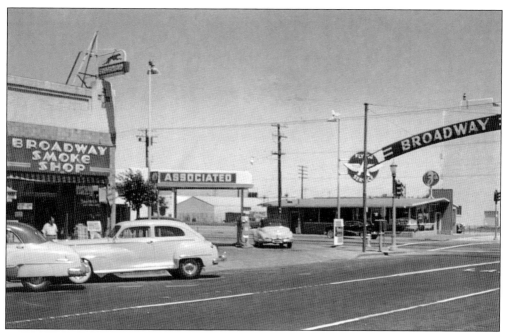

BROADWAY-BURLINGAME. Among the many Associated gas stations in San Mateo County, this facility stood adjacent to the historic arch on Broadway at California Avenue in Burlingame. This downtown station was convenient to local businesses in 1950, like Z's restaurant next to the Southern Pacific Railroad tracks and the Broadway Smoke Shop right next door. Today, the location is home to A&A Gas and Mart. (Authors' collection.)

BURLINGAME CHEVRON STATION. Located on a nice spot in downtown Burlingame was Howard Avenue Service, at the corner of Howard Avenue and Primrose Road. This independent dealer was one of at least six Chevron stations in the city of Burlingame. Most Chevron stations provided complete automotive repairs and stocked company-brand Atlas tires and batteries. (Authors' collection.)

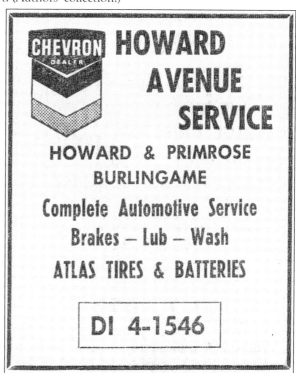

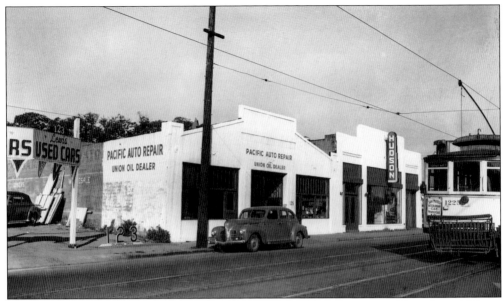

BURLINGAME, 1920s AUTO REPAIR. Pacific Auto Repair in Burlingame celebrated its 100-year anniversary in 2023. The garage was founded in 1923 at 127 California Drive as an automobile repair shop and Union Oil dealer by Herbert C. Vielbaum. (Vielbaum family collection.)

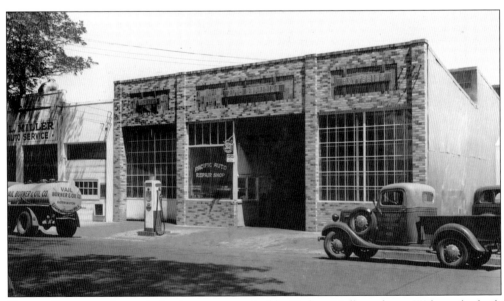

GARAGE EXPANSION. Later, the business was acquired by Herbert Vielbaum's son Walter, who built a larger garage in the 1930s behind the California Drive facility at 124 Highland Avenue. The shop continues to operate today, managed by Walter's son Gary. Pacific Auto Repair is the second-oldest business in Burlingame and is notable in that it has remained in the Vielbaum family for more than a century. (Vielbaum family collection.)

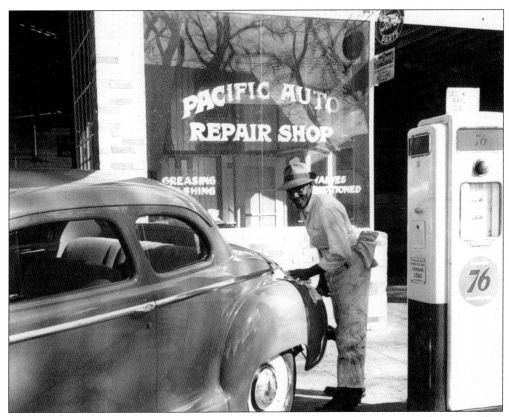

SELLING UNION 76. Tom Goodrey worked part-time washing and polishing customers' cars. Goodrey also worked for the Southern Pacific Railroad in the nearby tower controlling the crossing gates at South Lane, North Lane, and Howard Avenue. The single gas pump shown at the curb is a Union 76 Wayne Model 70. (Vielbaum family collection.)

TEAM PHOTOGRAPH. Employees of Pacific Auto Repair surround a 1928 Franklin Air Cooled Coupe in this mid-1980s view. From left to right are Jeff Mason, Paul Moran (kneeling), Neil Wind, Gary Vielbaum, Walter Vielbaum, and Harold Levinson. (Vielbaum family collection.)

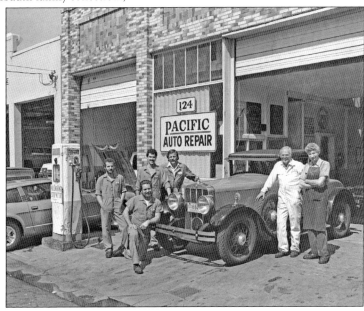

17

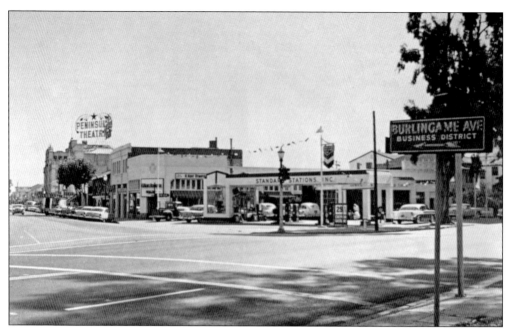

BURLINGAME, STANDARD STATION. Located at the corner of El Camino Real and Burlingame Avenue, at the entrance to the town's attractive shopping district, was this impressive Standard Oil station. All Standard stations were company owned, and Chevron brand stations were managed by independent dealers. Farther down the avenue was the majestic Peninsula Theater, which showed first-run movies from 1926 to 1974, when it was demolished. The Standard station was replaced by a Walgreens drugstore. (Burlingame Historical Society.)

BURLINGAME, PRIME LOCATION. Roy Schlightmann provided complete automotive service from his Chevron station at 1001 Howard Avenue, on corner of California Drive. Besides providing basic repairs, Schlightmann also installed auto mufflers and tailpipes, a somewhat rare revamp for gas stations. (Authors' collection.)

New Technology. In today's age of modern technology, so many conveniences are taken for granted. However, the late 1920s and early 1930s were a time of invention in the gasoline sales and automotive repair business. Pneumatic air lines lying on the shop floor were a trip hazard, and in bays with multiple lifts, one mechanic was always searching for a line. The invention of the Roto-Reel gave mechanics the safety and flexibility needed for a convenient and efficient shop. (Authors' collection.)

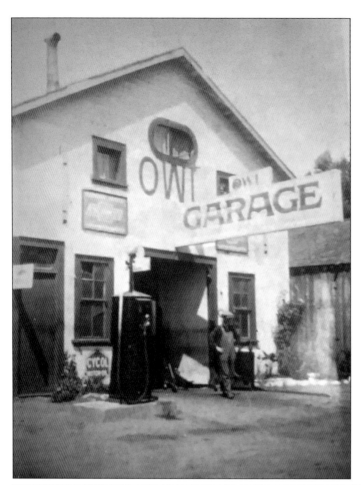

COLMA, OWL GARAGE. The Owl Garage was an early North County gas station and auto repair shop, located on Mission and B Streets. In 1916, the garage had a single pump, most likely a Gilbert and Barker or Bowser curb pump. The wife of proprietor Frank Marschall stands next to a 1917 Winton Model 48, an expensive car at the time at $3,500. (Both, Colma Historical Association.)

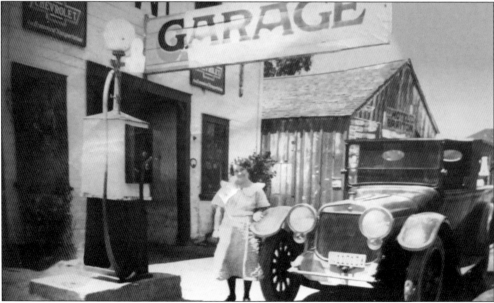

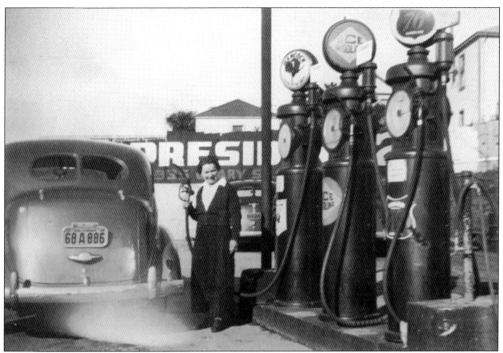

VARIETY OF BRANDS. The Marschalls continued to operate the Owl Garage into the 1940s. The garage's gasoline offerings have expanded to Hancock, Ace, and Union 76, now being dispensed from Tokheim 850 pumps that use a clockface and pointer to indicate how much gasoline has been pumped into the car. Clockface pumps did not compute the cost of the fuel being transferred. Shown below is the Marschall's Motor Fuel Pump License for the three Tokheim pumps. The fee was $1 per pump in August 1939. (Both, Colma Historical Association.)

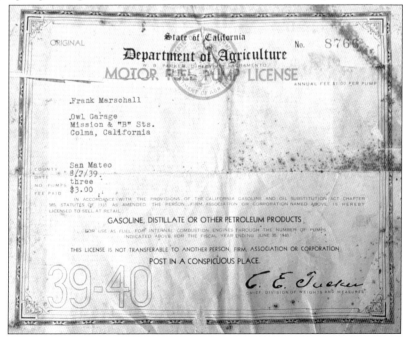

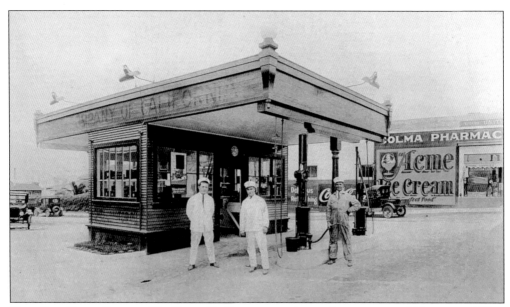

DALY CITY, EARLY STATION. The Teems Shell station on the southwest corner of Mission and West Market Streets served the burgeoning number of autos traveling up and down the peninsula. This c. 1916 photograph shows a number of Ford Model T sedans as well as a pickup truck at right. The attendant at right is holding the hose to a Boyle-Dayton Model 76 pump. This pump went into service three years before the visible era, and note that it does not have an advertising globe. (Colma Historical Society.)

DALY CITY, 1950s. Few motorists could miss seeing this Standard Oil station with its enormous porcelain and neon sign. This station was located at John Daly and Lake Merced Boulevards. This high-volume station across from the Westlake Shopping Center was one of Daly City's largest, with a total of 12 pumps. In the background of this 1955 image, construction is well underway on homes of the giant Westlake housing development. (DCHGMA.)

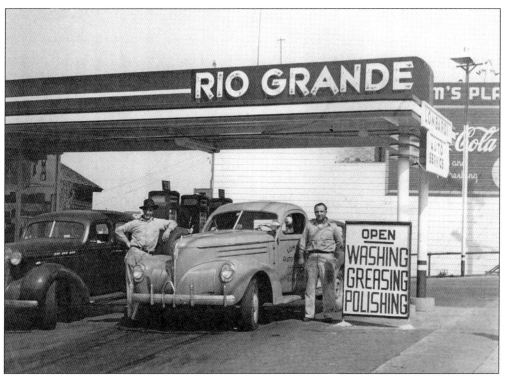

DALY CITY, RIO GRANDE STATION. Located at 6498 Mission Street at Theta Avenue was this Rio Grande station and Lombardi Auto Service. This facility was typical of the many neighborhood stations on the peninsula that provided full-service gasoline plus major automobile repairs all in one location. This rare prewar photograph shows some of the vehicles of that era, including an unusual 1939 Studebaker Coupe-Express, one of only 1,200 built in that year. Ahead of its time in styling, the vehicle featured a stylish, comfortable automobile cab connected to a one-half-ton truck bed, much like the Ford Ranchero built many years later. (Both, Jeff Nielsen collection.)

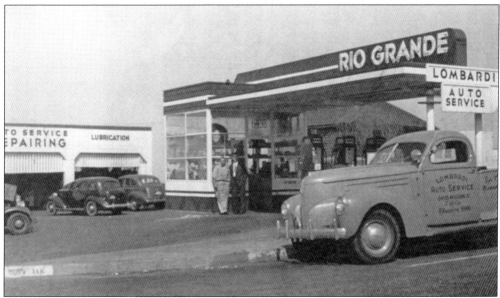

23

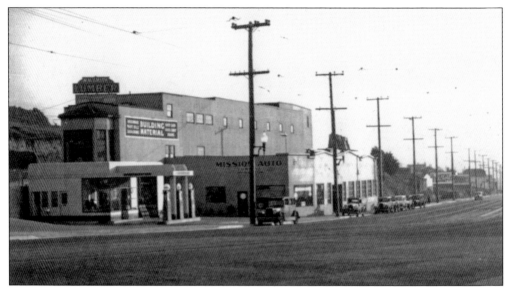

DALY CITY, EARLY DAYS. A Shell station sat at the corner of Mission Street and Hillside Boulevard as seen in this 1933 view. Notice how the shell-shaped globes on top of the pumps are faced, with one up the street, the center toward the boulevard, and the farthest facing motorists approaching from the south. Mission Auto occupies the building to the south while the H.H. Smith Lumber Co. occupies the large structure to the rear. (DCHGMA.)

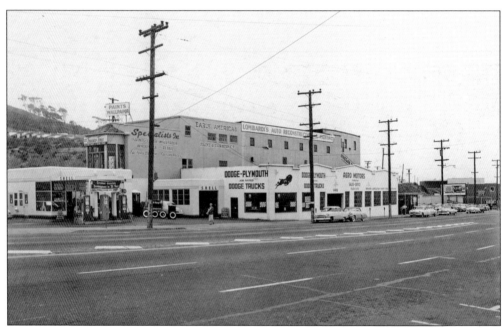

STATION EVOLUTION. By the mid-1950s, Mission Street has been striped and the Shell station has added a single repair bay adjacent to the Aero Motors building. The Shell station is promoting its new TCP gasoline additive with a large banner and rotating signs on the pump to the right. Aero Motors offered sales, and its service bays were accessed through the large roll-up door in the center of the building. (DCHGMA.)

24

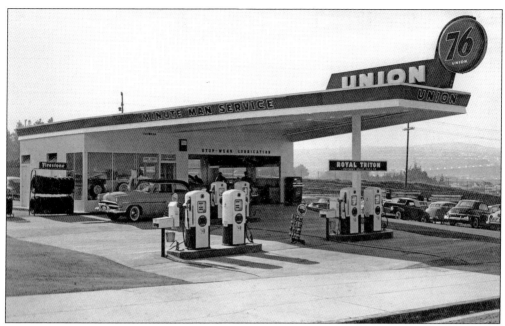

DALY CITY, UNION 76. Located at 101 South Mayfair Avenue, just off busy John Daly Boulevard in Daly City, was this attractive Union 76 station. Built at a prime location, this station was near the entrance to Henry Doelger's sweeping Westlake subdivision. Six Bennett pumps, three regular and three premium grade gasolines, denote that this was a busy station. This image from 1953 advertises Royal Triton oil, which was a rich purple in color; Firestone tires; and "Minute Man Service," a Union Oil slogan for many years. Currently, an Alliance station occupies this location. (DCHGMA.)

DALY CITY, FLYING A. Louis "Lou" Nannini was a pioneer in the North County gasoline business. He opened an Associated (Flying A) station in 1943, as seen in this wartime photograph of Mission and School Streets. Service was always Nannini's motto, and Lou and his crew, including a woman attendant, are shown providing customers full service on their 1940 Chevrolet and 1935 Ford automobiles. (Dave Nannini collection.)

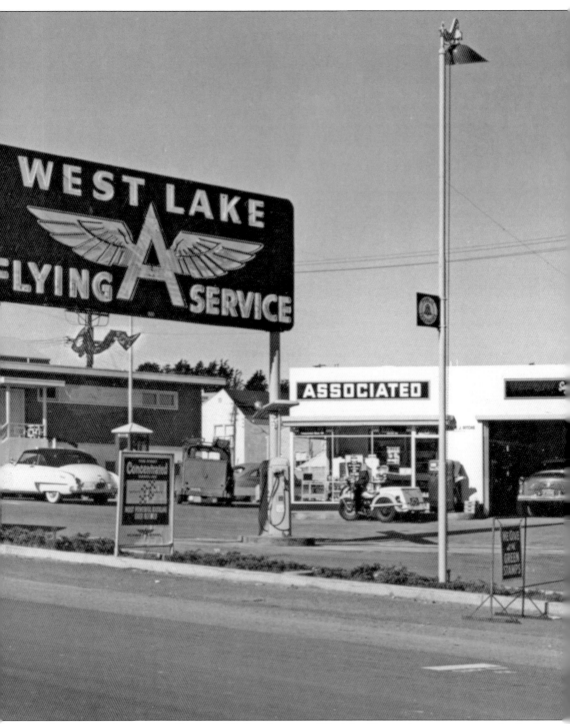

DALY CITY, ASSOCIATED STATION. Under the giant Westlake Flying A neon sign was Leslie J. Ritchie's Associated station at 950 John Daly Boulevard. This 1954 image shows that the station was a busy place with all four repair bays filled with vehicles and six pumps ready to service large volumes of motorists. Moreover, this station was located on a busy street, open all night, and was

next to the popular Westlake Joe's Restaurant. Also shown in this photograph is a three-wheel Harley-Davidson motorcycle commonly used among gas station owners to pick up and deliver customer's cars. (DCHGMA.)

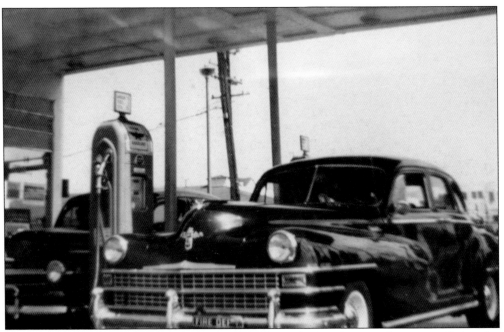

DALY CITY, FIRE CHIEF. Seen here at the pumps of his Daly City Associated station is Colma fire chief Louis Nannini's 1947 Chrysler. Nannini served his community well as a kind and considerate merchant as well as a fire chief for 10 years in the nearby town of Colma. (Dave Nannini collection.)

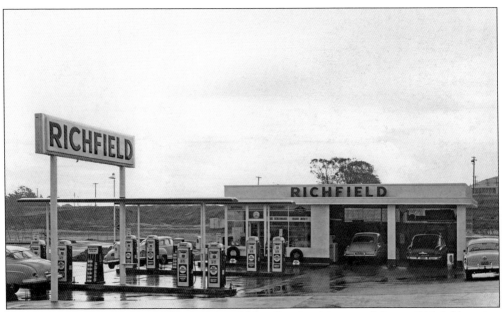

DALY CITY, RICHFIELD STATION. Motorists could hardly miss this state-of-the-art Richfield station on John Daly Boulevard at the entrance to the Westlake District. Developer Henry Doelger began building homes there in 1947. Along with housing came the need for shopping centers, restaurants, and service stations. On this rainy day in 1952, two 1949 autos—an Oldsmobile and a Mercury— are in for repairs in the service bays while a newer Mercury waits in the wings. (DCHGMA.)

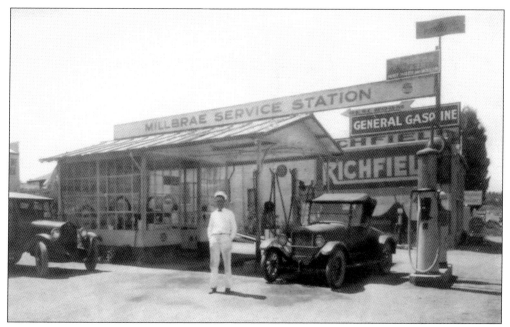

MILLBRAE, PUMP CHANGEOVER. One of the earliest gas stations in town was this Richfield station located along the El Camino Real. This station also pumped General gasoline, as shown in this 1920s image. It appears that this station was switching to more modern equipment, as the two Wayne 10-gallon visible pumps at the right are replacing the much older Bowser pumps to the rear. The automobile is a 1926 Ford Model T roadster. (Authors' collection.)

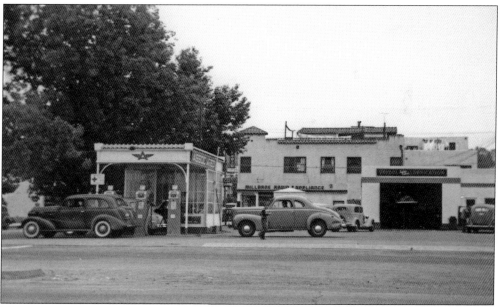

MILLBRAE, NATIONAL GAS PUMPS. This Associated station was located at Hillcrest Boulevard and El Camino Real and was one of the many Flying A stations constructed in San Mateo County in the 1920s. The small steel and glass office was a prefabricated unit delivered and assembled on-site in several days. This 1940s image shows three modern National gas pumps and a 1940 Nash coupe and a 1938 Chevrolet sedan waiting to be fueled. (SMCHA 1992-003.)

In "MILLBRAE" It's

MOSS & BLAIR
MOBIL PRODUCTS

- AUTO REPAIR
- TUNE-UPS
- HYDRAMATIC SERVICE
- BRAKE WORK

Tires – Batteries – Accessories

OX 7-9706 - OX 7-5616

EL CAMINO RL. & HILLCREST BLVD.
MILLBRAE

MILLBRAE, AUTO SERVICE. Moss and Blair's Mobil station once shared the corner of Hillcrest Boulevard and El Camino Real with Spackman's Richfield station. In addition to providing Mobil products, Moss and Blair repaired Hydramatics, the earliest and most successful General Motors fully automatic transmission first installed in 1939 Cadillacs and Oldsmobiles. (Authors' collection.)

 In **MILLBRAE** It's
GORDON'S
SHELL SERVICE

COMPLETE LUBRICATION SERVICE
MOTOR TUNE-UP – BRAKE WORK – MUFFLERS & TAIL PIPES
GOODYEAR TIRES & ACCESSORIES – DELCO BATTERIES
FREE PICK-UP & DELIVERY
WE GIVE S & H GREEN STAMPS
Mon. Thru Thurs. 6 'til 10. Fri., Sat., Sun. 6 'til 11

—CALL—
OX 7-1642 - OX 7-9948

SKYLINE BLVD. & MILLBRAE AVE. MILLBRAE

MILLBRAE, SHELL STATION. Today, only a weed-covered vacant lot marks the former location of Gordon's Shell Service at Skyline Boulevard and Millbrae Avenue. Gordon's was a quiet, friendly neighborhood mainstay far from the hustle and bustle of the downtown area. (Authors' collection.)

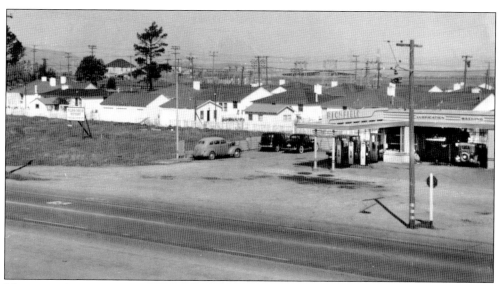

MILLBRAE, RICHFIELD STATION. Spackman's Richfield station was located at El Camino Real and Hillcrest Boulevard. Richfield Oil Corp. was a California-based company formed in 1905 that, many years later, merged with Atlantic Refining Co. to form today's ARCO. Richfield stations were yellow and blue with stylized eagles displayed on their pumps and neon signs. This station was built in the Streamline Moderne fashion popular in the 1930s and 1940s. (Tom Dawdy family collection.)

MILLBRAE, CUSTOMER SERVICE. Arteseros Chevron Service on the corner of El Camino Real and Taylor Boulevard served the downtown area for many years. Like most vintage service stations in San Mateo County, Arteseros offered pick-up and delivery at no charge to the customer. The legacy of Arteseros continues today, albeit with a modern Chevron station on this site and with different owners. (Authors' collection.)

31

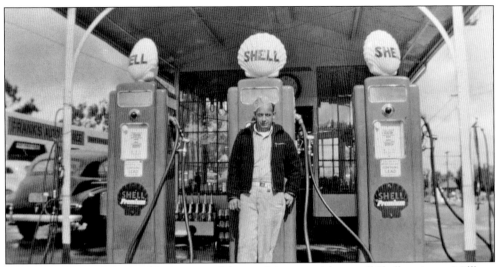

MILLBRAE, DAWDY SERVICE. After a successful run of six years with a small Shell station at Millbrae Avenue and El Camino Real, Glen Dawdy, seen here at that station, opened a second, larger, and more modern Shell station at 500 Broadway in 1954. The new station provided complete automotive services. Dawdy passed away in 1973, but his son Tom continued to run the business until 1980, when the station closed. (Tom Dawdy family collection.)

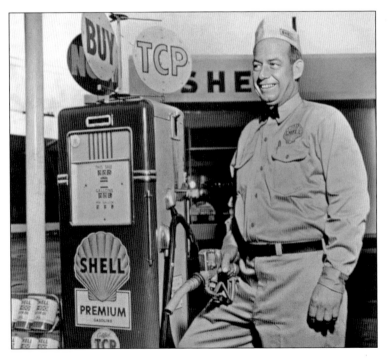

BOWSER PUMPS. Looking sharp in his immaculate uniform with bow tie and hat is Glen Dawdy, owner of Dawdy's Shell Service at 500 Broadway. The gas pump is a Bowser 575 Premium model used by Shell from 1952 to 1957. Advertised atop the pump is TCP, a Shell additive used to improve automobile engine performance. To the left of the pump is a rack of Shell's famous X-100 motor oil. (Tom Dawdy family collection.)

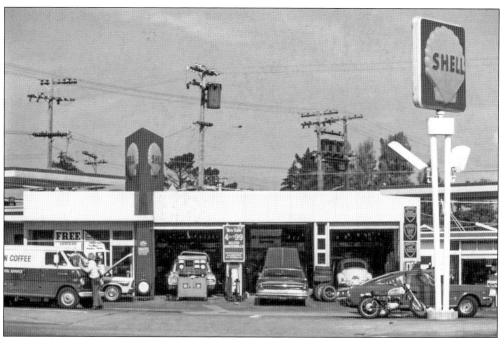

FULL-SERVICE BAYS. Business was good when this 1972 photograph was taken showing the pumps and service bays fully occupied at Dawdy's Shell Service on Broadway at Taylor Boulevard. Many motorists moved from dealer service to service stations, as evidenced by the 1964 Chrysler 300 in the center bay while both the Ford Mustang fastback and the VW on the rack are 1966 vintage. (Tom Dawdy family collection.)

TAKING CARE OF BUSINESS. This newspaper advertisement appeared in the *Millbrae Sun* showing Glen Dawdy and six of his attendants and mechanics in front of his station on Broadway. This was the first job for many of his employees. They were well-trained by Dawdy and treated with respect and patience. In turn, the employees treated the motorists in the same manner, which resulted in many happy repeat customers. (Tom Dawdy family collection.)

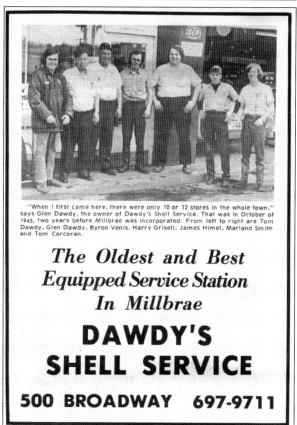

"When I first came here, there were only 10 or 12 stores in the whole town," says Glen Dawdy, the owner of Dawdy's Shell Service. That was in October of 1945, two years before Millbrae was incorporated. From left to right are Tom Dawdy, Glen Dawdy, Byron Venis, Harry Grisell, James Himel, Marland Smith and Tom Corcoran.

The Oldest and Best Equipped Service Station In Millbrae

DAWDY'S SHELL SERVICE

500 BROADWAY 697-9711

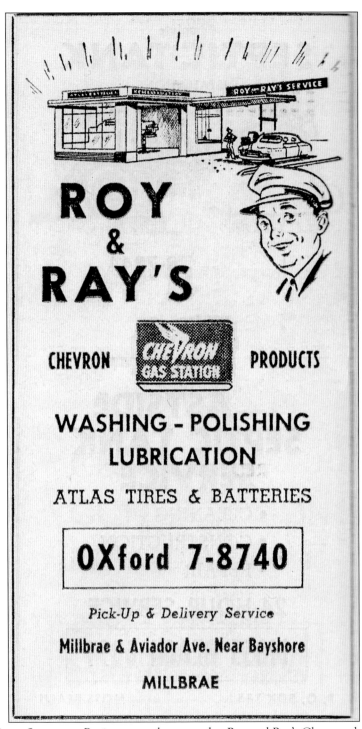

MILLBRAE, PRIME LOCATION. Business was always good at Roy and Ray's Chevron due to its prime location near the San Francisco Airport. On Millbrae Avenue at Aviador Street, it was also adjacent to the busy Bayshore Highway. Although Roy and Ray are gone, a large Chevron station remains today at that key intersection. (Authors' collection.)

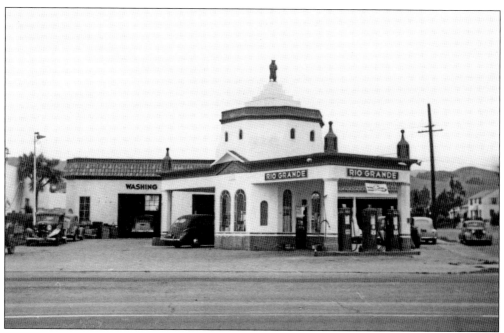

MILLBRAE, RIO GRANDE. This Rio Grande station at El Camino Real and Taylor Boulevard was truly "grand" in its style. Designed in a Spanish Colonial Revival theme, this striking station featured an elaborate dome, arched windows, and decorative pediments at each corner of the building. To the rear of the filling station, an automobile garage provided full-service repairs, including washing, waxing, oil changes, tune-ups, and tire service as well as engine rebuilding. (SMCHA 1992-003.)

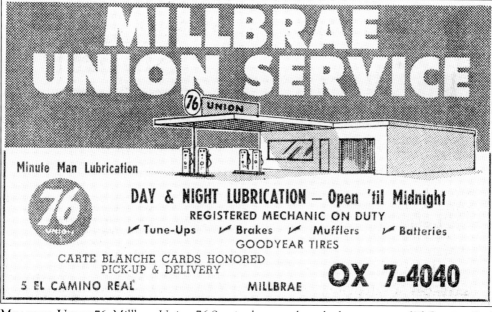

MILLBRAE, UNION 76. Millbrae Union 76 Service has stood on the busy corner of El Camino Real and Millbrae Avenue for over 70 years offering, in addition to gasoline, full automotive repairs and late hours to accommodate the many nearby San Francisco Airport workers and travelers. (Authors' collection.)

35

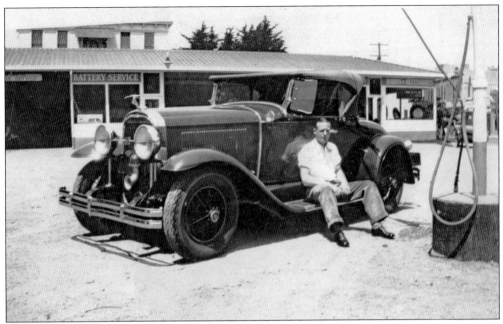

SAN BRUNO, EARLY DAYS. Henry Baccala sits on the running board of this 1930 Buick Series 60 Roadster in front of a town gas station at the corner of El Camino Real and San Mateo Avenue on April 30, 1930. This property was formerly the Junction House, built by August "Gus" Jenevein in 1889. Baccala's Buick was quite the car, having a retail price in 1930 at the height of the Great Depression of $1,585. (San Bruno Public Library.)

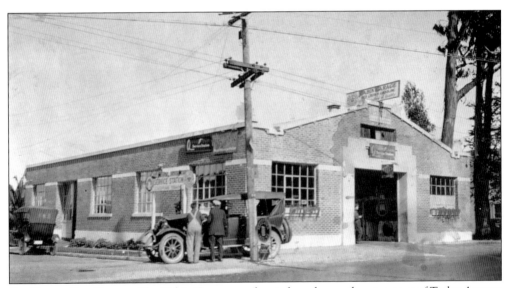

SAN BRUNO RED CROWN. The Cabin Garage was located on the southeast corner of Taylor Avenue and El Camino Real and owned and operated by Gus Jenevein. Jenevein, who has a street named after him in town, was the proprietor of the San Bruno House as well as the Cabin Garage. The garage sold Red Crown gasoline and is seen here in the early 1920s. (San Bruno Public Library.)

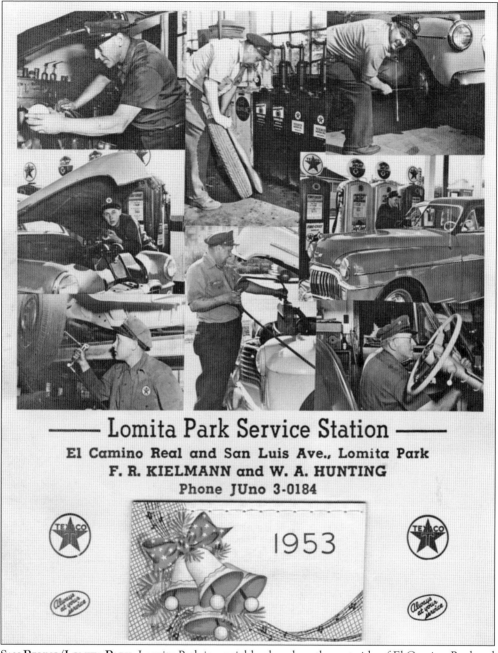

SAN BRUNO/LOMITA PARK. Lomita Park is a neighborhood on the east side of El Camino Real and was an unincorporated part of the county until it was annexed by San Bruno in 1953. From that same year is the area's Texaco station calendar with a collage showing the staff in action servicing cars. The station was owned and operated by F.R. Kielmann and W.A. Hunting and was located at 425 El Camino Real and San Luis Avenue. Notice the Bennett Model 646 pumps with globes signifying which grade of gasoline each dispensed. (Photograph by Ray Richardson.)

SAN BRUNO, SIGNAL OIL. El Camino Real and Jenevein Avenue was home to a Signal Oil station on the northwest corner and a Mobil station across the street. Mobil station owner Victor L. Podesta had a large S&H Green Stamps sign above the awning sheltering the pumps. S&H distributed stamps and collection booklets from 1896 to the early 1980s, and full books could be redeemed for housewares all the way up to furniture. (SMCHA 2020.35.67-26330.)

SAN BRUNO, SHELL STATION. The Shell station on the corner of San Bruno Avenue and Glenview Drive (to the right side of the station) is doing a brisk maintenance business with two cars in the service bays and a Cadillac on a jack to the right. A number of finished vehicles await their owners to the right. Today, the site of this station is an empty lot. (SMCHA 2020-035-104-41065.)

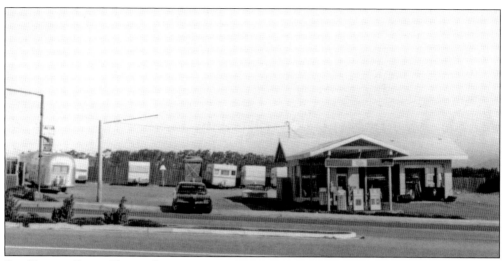

SAN BRUNO, ENCO. This is the Enco station on San Bruno Avenue as seen from the Skycrest Shopping Center with a 1968 Pontiac GTO about to make a left turn having filled up with gas. An attendant's 1959 Chevy Bel Air sits at the side of the station. Although hard to see, under the awning along the front of the building is the Humble Oil sign, owners of the Enco brand. (SMCHA 2020-035-104-41063.)

"ETHYL" GAS. When people pulled up to the pump, attendants would ask, "Regular or ethyl?" Ethyl, short for tetraethyllead, refers to the lead-based, antiknock compound introduced in 1923, which increases the fuel's octane number. The higher octane number ensures that fuel injected into the cylinder will completely combust. Unburned fuel that ignites after the initial ignition causes a knocking sound and is hard on engines. The introduction of unleaded fuel for automobiles effectively ended its use. (Authors' collection.)

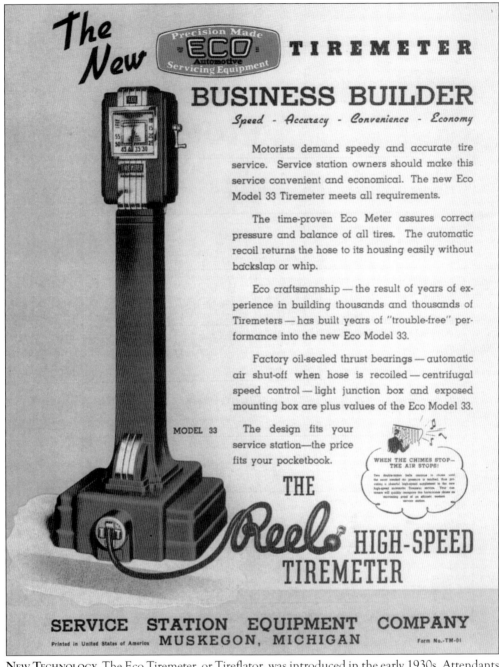

NEW TECHNOLOGY. The Eco Tiremeter, or Tireflator, was introduced in the early 1930s. Attendants would set the desired pressure with the turn of a handle, which registered on the machine's face. The Tiremeter would automatically pump the set pressure. Various models of Tiremeters could be found at pump islands, often with one meter at each end enabling attendants to service the front or rear without dragging the hose across the car. (Authors' collection.)

SOUTH SAN FRANCISCO. The northwest corner of Westborough and Gellert Boulevards in South San Francisco was home to an Enco service station, as seen in this December 1969 view. In addition to fuel, the station featured two service bays. Today, it is operated as an independent Fuel 24:7 station; the service bays have been enclosed and replaced by a mini-mart and sandwich shop. (SMCHA 2015-001-06094.)

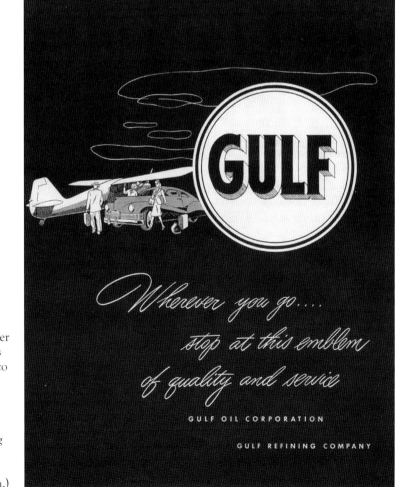

NATIONAL BRANDS. Gulf Oil Corp. was one of the first retailers to sell branded gasoline, the contents of which buyers could be assured were of the highest quality. There were a number of Gulf Oil retailers on the San Francisco Peninsula, and its aviation gasoline was pumped at many of the local airports that sprung up in the post–World War II era. (Authors' collection.)

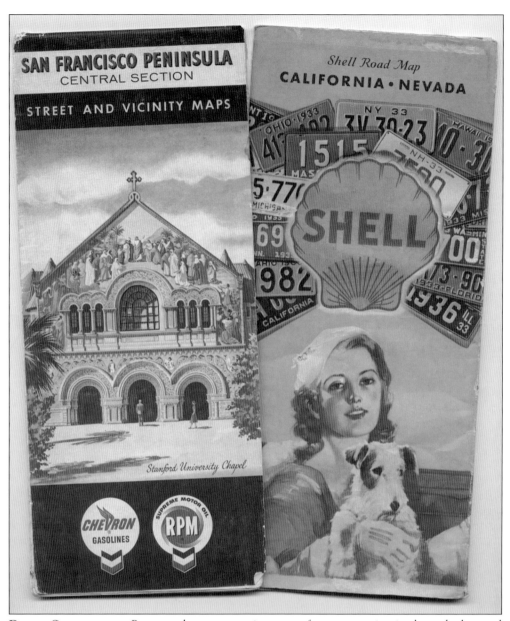

DRIVER CONVENIENCES. Paper road maps were given away free to motorists in the early days and later sold for less than $1 as paper prices increased and station operators were looking to increase revenue streams. Most had colorful front covers, such as these examples showing a collection of license plates on the 1933 Shell map and the Stanford University Chapel on the front cover of a 1961 Standard Oil road map of the San Francisco Peninsula. (Author's collection.)

Two

CENTRAL COUNTY
BELMONT, FOSTER CITY, FARALLONE CITY, HALF MOON BAY, MONTARA, PACIFICA, AND SAN MATEO

Located at the center of San Mateo County and the midpoint of the San Francisco Peninsula are the towns of Belmont, Foster City, Half Moon Bay, and San Mateo. This area is the crossroads for drivers heading to or from San Francisco, San Jose to the south, and the East Bay when crossing the San Mateo-Hayward Bridge. As roads improved in the post–World War II years, gas stations sprang up at key intersections to offer services to both the leisure traveler and later to those commuting through the county to the peninsula's centers of industry.

In San Mateo, at least three stations were constructed on El Camino Real at Third Avenue to attract customers traveling on two of the busiest streets in that city. None were built in Hillsborough, owing to the town's desire to remain residential in nature. Later, when the Bayshore Highway was completed as far as San Mateo, additional filling stations were hastily built on Third Avenue and Bayshore Highway and Nineteenth Avenue and Bayshore Highway, two key routes to the newly opened San Mateo-Hayward Bridge.

On the coast in tiny towns like Montara, gas and oil pumps were often added to remote hotels, garages, and grocery stores. There the motorist could have dinner, spend the night, buy groceries, and gas up their automobile. In Half Moon Bay, the first real gas station was built at the intersection of Main Street and San Mateo Road, today's Highway 92.

Skyline Boulevard and the Ocean Shore Highway (later designated as Highway 1) were also constructed in the 1920s, and their completion brought several stations to the hilltops and coastal communities of Edgemar, Salada Beach, Brighton, Sharp Park, Linda Mar, and Rockaway Beach (later incorporated into the city of Pacifica).

It is interesting to see the variety of gasoline brands that were once prevalent that are now gone, such as Associated's Flying A, Mohawk, Red Crown, Richfield, and Signal Oil. Each had its loyal following and directed its advertising to reach certain segments of the motoring population—commuters needing tires or services or housewives in search of S&H Green Stamps redeemable for household goods.

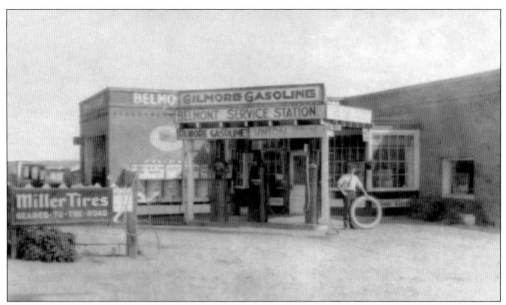

BELMONT, GILMORE STATION. Pictured here is a mid-1920s view of the Gilmore gas station on El Camino Real in the city of Belmont. Tires were always a problem on early roads of the time, with sales and service being a profit center for station owners. Many stations of the era also sold various brands and grades, as the Belmont Gilmore station also sold Union Oil gas. (Authors' collection.)

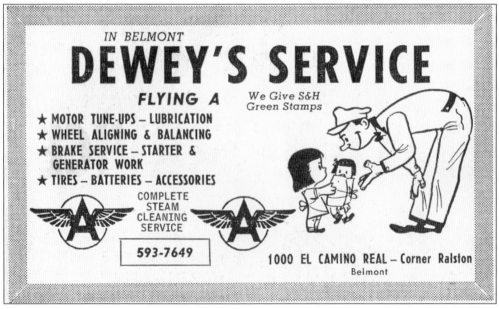

BELMONT FLYING A. Dewey's Flying A, a small three-pump station, was once located on the busy corner of El Camino Real and Ralston Avenue. Previously, Dewey's was a Shell dealer. The station was demolished in the early 1970s. The site is currently home to the Biergarten at the Belmont Village Center. (Authors' collection.)

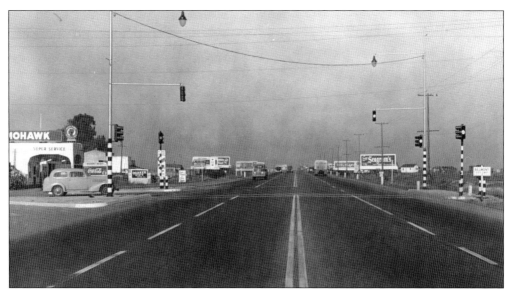

BELMONT, MOHAWK SERVICE. Most major intersections along the Bayshore Highway contained at least one gas station. This was the case at Ralston Avenue and Bayshore Highway on a cloudy day in 1948. The Mohawk Super Service station, owned by Ernest Pasterino, stood for many years until the highway was reconstructed into a freeway (as far as San Carlos) in 1954, and the station was torn down. (BHS.)

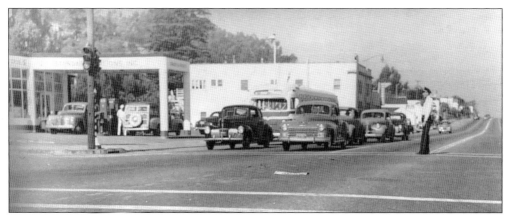

BELMONT, PEDESTRIAN SAFETY. A Standard station on the corner is shown in this view of El Camino Real and Ralston Avenue in the late 1940s. Traffic was stopped each evening around 6:00 p.m. by a police officer (center) to allow the throngs of commuters to safely cross El Camino Real following their arrival at the nearby Southern Pacific train depot. (BHS.)

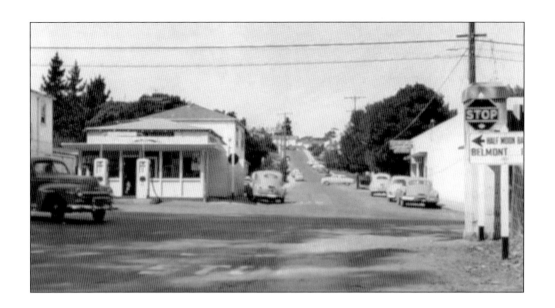

BELMONT, COMMUNITY ENGAGEMENT. Aside from offering the usual oil company products and services, the station on Ralston and Villa Avenues has been extremely active in the community for decades, sponsoring bowling and Little League teams as well as hosting school and Scouts fundraising car washes. In the late 1960s, Ray Knorr was active in the Northern California Kidney Foundation and was chairman of the Shell Dealers Kidney Fund. Typically, the stations would donate a certain amount per gallon sold to the fund. Knorr sold his interest in the station in early 1965, and it has continued to dispense Shell gasoline to this day. (Both, BHS.)

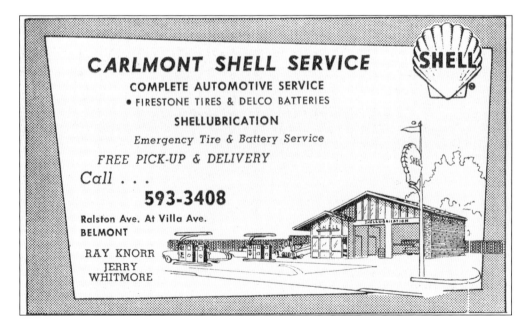

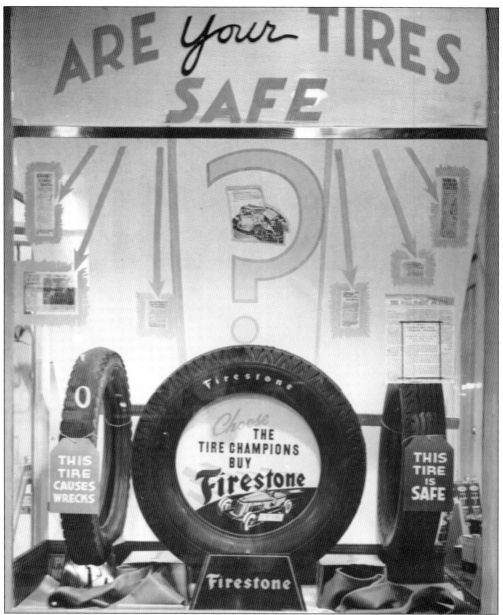

FOSTER CITY, SERVING THE COMMUNITY. The first residents moved into the master-planned community known as Foster City, named after its developer T. Jack Foster. Built on Brewer Island, once part of the Leslie Salt Company's vast landholdings ringing the lower San Francisco Bay, Foster City today boasts nearly 34,000 residents. When the community first opened in the mid-1960s, stores, gas stations, and other services came with the tracts of houses and apartments. The 20,000-square-foot Safeway grocery store opened in late 1965, and gas stations followed as each neighborhood was built. This photograph from one of the city's first gas stations shows the variety of reasons motorists need to stay on top of tire wear. The recommended type of tire was Firestone. (Authors' collection.)

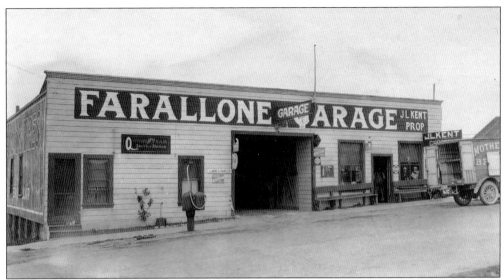

MONTARA/FARALLONE CITY. The Farallone Garage and store was one of the original structures built in the tiny village of Farallone City, founded in 1906. Located on Main Street and operated by Jacob Kent, the store sold groceries and bakery goods along with Red Crown gasoline. The single gasoline pump was a 1912 Bowser Red Sentry curb pump. The building burned down in 1920 but was replaced by a similar structure called Kent's Store, which survived until 1971. (SMCHA 0001-859-069.)

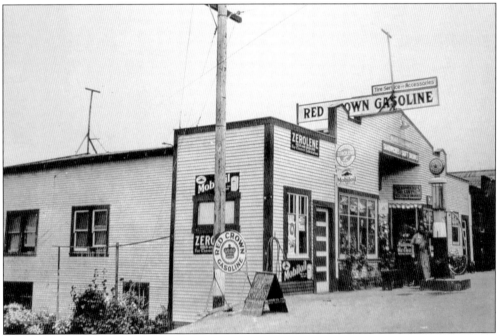

MONTARA, RED CROWN PUMP. Later known as the Montara Inn, this Red Crown gas station was located at 1361 Main Street. The shop offered food and drink to travelers making the journey north or south on the Ocean Shore highway. Proprietress Marie Kullander can be seen in the shadow of the visible pump. Years later, Main Street would be bypassed when the bankrupt Ocean Shore Railroad's roadbed was used for Highway 1. (SMCHA.)

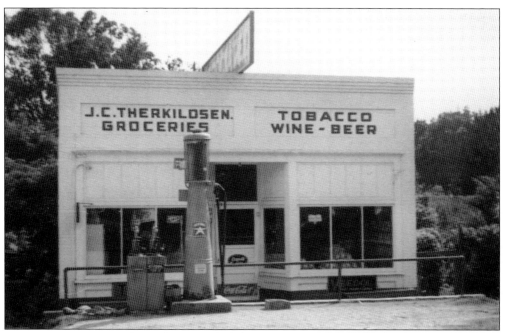

MONTARA, ASSOCIATED GAS. The J.C. Therkilosen store in Montara began life in 1912 at 790 George Street as a bakery operated by Charles Krieger. Later, it became a grocery run by the families of DeCesares, Benedettis, and finally, the Therkilosens. In this 1930s image, Associated gasoline was dispensed from the single Gilbert and Barker 10-gallon hand crank visible pump. Two nearby "lubesters" provided motor oil. This building still exists as a private residence. (SMCHA 1992-008-Montara.)

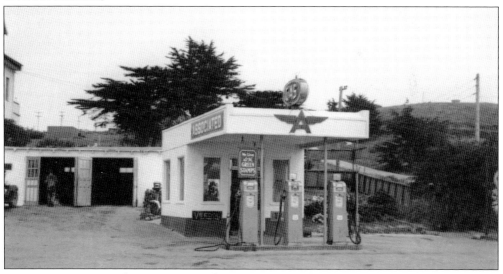

MONTARA, FLYING A. This 1940s image shows an Associated or Flying A station at 8445 Cabrillo Highway (Highway 1). This station was once owned by Mr. and Mrs. Lawrence Walker, but the ownership changed in 1948 when the Walkers sold the station to Pete McLeroy. As with most Flying A stations, gasoline was dispensed through three National brand electric-powered pumps, as shown in this photograph. Auto and truck repairs were provided at the rear of the station in a small garage. (SMCHA 1992-008-MON-01-02.)

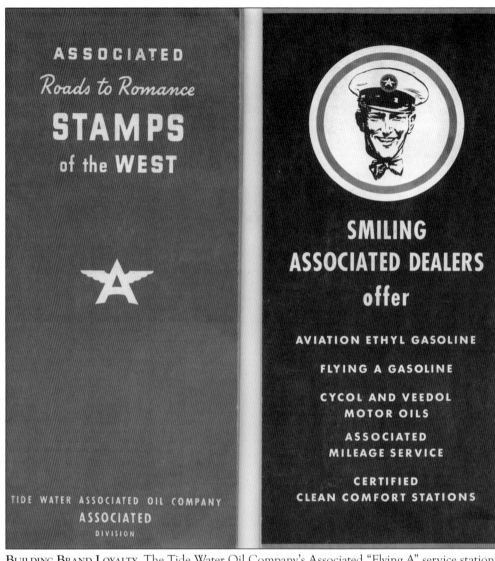

BUILDING BRAND LOYALTY. The Tide Water Oil Company's Associated "Flying A" service stations began distributing stamp albums in 1938. The first year's album was *Stamps of the West* and featured two-color printed stamps that were attractive and educational at the time. Under each stamp was a short description, covering such topics as early transportation, national parks, missions, and beauty spots of the West. In 1939, a new album *Stamps of the West: Roads to Romance*, shown at left, was introduced. Every few pages, there was a discreet, educational tip about car care, what services Associated stations offered, and why a motorist would need them. Stations were giving away one stamp every week for 22 weeks, and dealers in other areas had different stamps. This encouraged motorists to patronize their local Associated station and to stay brand loyal when taking out-of-town driving trips. (Mark Weinberger collection.)

MONUMENTAL AND EXOTIC are the twin Towers of the East, each with its *ghat* (in India a bathing stair and cremation site) for pageants, that command the broad esplanade facing the Pacific Nations Lagoon and guard the eastern entrance to the Court of Flowers. Huge bas-reliefs finished in gold, "Dance of Life" and "Path of Darkness," adorn the Tower forms.

OF HEROIC PROPORTIONS, and dominating the court of the same name, is the Statue of Pacifica, its 80-foot height approximating that of a 7-storied building. From the base of this imposing statue, backed by a lacy curtain of metallic star-shapes that whisper to the gentle breeze, a limpid cascade tumbles into the statue-ringed Fountain of Western Waters below.

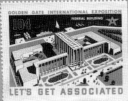

SEE YOUR GOVERNMENT AT WORK in the magnificent Federal Building with its impressive 48-columned Colonnade of States, 104 feet high by 265 feet long. Three aisles through the Colonnade symbolize the Executive, Legislative and Judicial branches of the government. Murals portray the conquest of the West and America's rich heritage of natural resources.

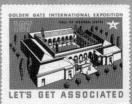

WONDERS OF A MILLION SQUARE MILES are gathered together in the Hall of the Western States, where you'll stroll through a $1,000,000 relief map built on a scale of one inch to the mile and so large that the state lines are footpaths. Here you'll see at close range the West's national parks and mountain ranges, its rivers, cities and highways.

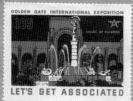

PREDOMINANTLY GOLD IN COLOR, the Court of Flowers contains 45,000 flower plantings of 46 different varieties, is approached from the Court of Reflections through the majestic Arch of Triumph. In this Court of Flowers, marking the eastern terminus of the great exhibit palaces, you'll hear the refreshing liquid song of the main Rainbow Fountain.

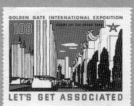

MASSIVE BOWSPRIT CORNICES grace the Court of the Seven Seas, announce and repeat the nautical motif of this gracious court containing 215,000 flower plantings in yellow and white. Too, wall murals depicting historic marine encounters, sculptured models of famous ships and picturesque lamp-posts fashioned like "crow's-nests" accent the salty flavor of the scene.

GOLDEN GATE INTERNATIONAL EXPOSITION. The first four pages of the 1939 album featured scenes from the Golden Gate International Exposition, held February 18 through December 2, 1939. Known as the GGIE, it was a huge Pacific Rim showcase of nations, art, and history and featured educational exhibits—including automotive displays by Ford and General Motors—as well as a carnival entertainment zone. Fairgoers were encouraged to take public transportation, but many elected to drive using the then three-year-old San Francisco-Oakland Bay Bridge. Following the GGIE album pages were stamp themes such as birds, flowers, trails (Spanish, Oregon, Overland, and Gold Trails), famous trees of the West, and others. Those motorists collecting the stamps were also encouraged to ask their friends and neighbors who might be traveling to stop at Associated stations to pick up stamps as well. Although a simple marketing plan, it was quite effective. (Mark Weinberger Collection.)

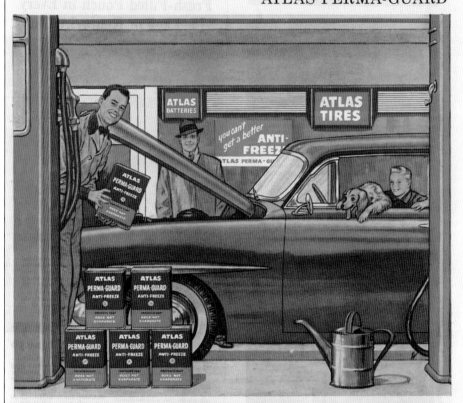

HOUSE BRAND. The Atlas Supply Co. of Newark, New Jersey, was founded in 1929 by the Standard Oil Co. of New Jersey. The Atlas brand became the gas retailer's house brand, offering everything a motorist could need, from antifreeze fluid to batteries to tires and related accessories. In 1951, Atlas Supply got into trouble with the Federal Trade Commission (FTC) for undercutting the prices of its competitors with subsidies from Standard Oil, violating US antitrust laws. In 1995, Atlas Supply Company's major shareholders—Chevron U.S.A. Inc. and BP Exploration and Oil Inc.—sought termination of the FTC's order. In 1997, Atlas Supply was acquired by a private equity consortium that held the company until 2015. At that time, the company was acquired by Linglong Americas Inc., which continues to sell the Atlas line of automotive products. (Authors' collection.)

HALF MOON BAY, ASSOCIATED STATION. This Spanish-style Associated station once stood at the intersection of Main, Purisima, and Filbert Streets. It was known as Pete and Bill's Flying A; later, it was owned by Richard Olson, who sold it to W.H. Rickords in 1950. The station featured "Aero-Type" gasoline and S&H Green Stamps with every purchase. Customers could also have keys made and purchase ice from the adjacent Peninsula Ice Company. (SMCHA 1992-008-HMB-05-01.)

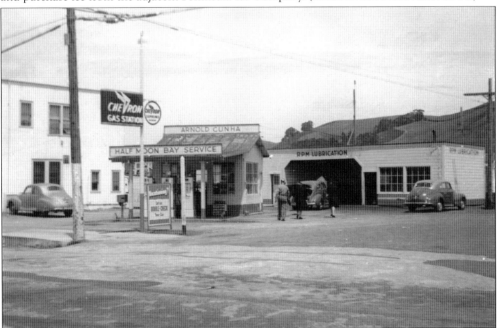

HALF MOON BAY, GATHERING PLACE. Advertised as being "in the center of town," Cunha's Chevron Half Moon Bay Service was typical of downtown gas stations often located in central business districts. At Main Street and Kelly Avenue, the Cunha brothers, Arnold and Harold, provided full-service gasoline, and the station was also a convenient gathering spot for residents to meet, chat, and discuss issues of the day. (SMCHA 1992-008-HMB-03-09.)

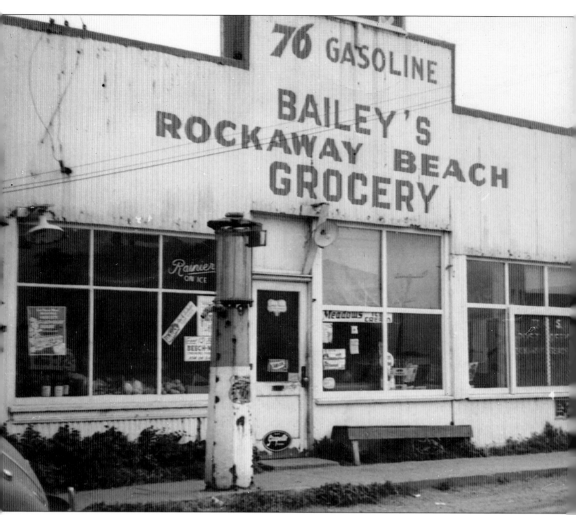

PACIFICA, EARLY UNION 76. The salt air in the area has taken its toll on the facade of Bailey's Rockaway Beach Grocery and Union 76 station in this pre–World War II photograph. William Edgar Bailey bought the store in 1927, which was also the town's post office. Around the side of the building to the right were the station's service bays. Bailey served as postmaster until 1935, when his wife, Coletha, took over the position. Coletha sold the business to Paul R. Farrell in 1945, following his service in the US Navy. The next year, Farrell sold the business to Arly Johnson and his wife, who kept it until 1949. Months later, Carl Horner and his wife bought the store and changed the name to Horner's Grocery. (PHS.)

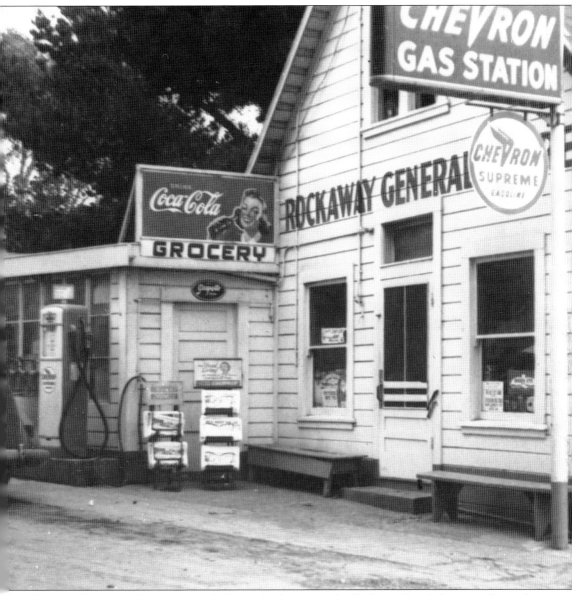

PACIFICA/ROCKAWAY BEACH. Louise's Store, also known as the Rockaway Beach Store, was located at Coast Highway and Rockaway Beach Avenue. This store was built in 1920 and, at one time, had the only telephone in the area. In addition to selling groceries and gasoline, over the years the store has doubled as a bus station, liquor store, post office, and a place one could go for first aid before making the trip to San Francisco for further treatment. The single Chevron gas pump was a welcome sight on the coast for travelers who were low on gas. (PHS.)

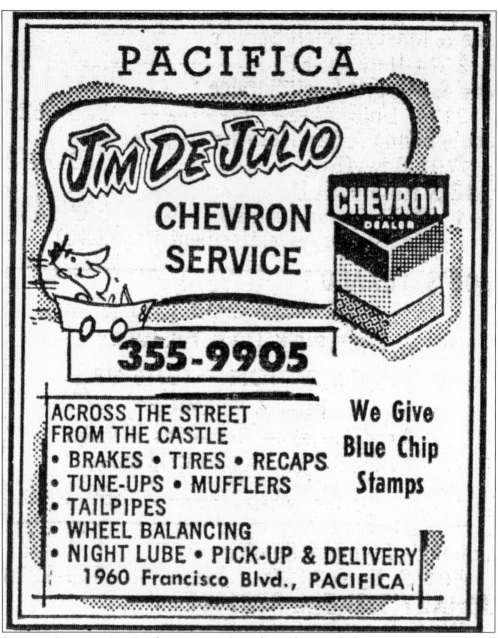

Pacifica, Chevron. Jim DeJulio was an independent Chevron dealer on Francisco Boulevard who advertised as being "across the street from the Castle," an imposing fire and earthquake-proof structure built by Ocean Shore Railroad attorney Henry McCloskey in 1908. Like many gas stations in Pacifica, DeJulio's was torn down when the Highway 1 freeway construction divided Pacifica in the 1960s. (Authors' collection.)

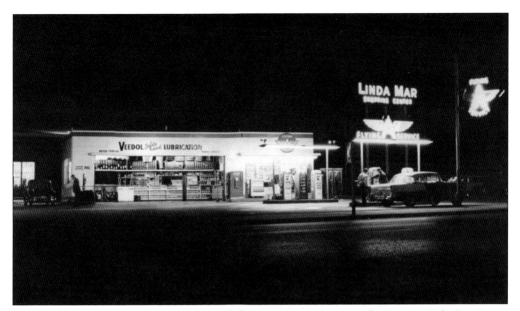

PACIFICA/LINDA MAR BEACH. After successfully operating an Associated station in Daly City, Louis Nannini opened a similar facility on the Coast Highway at Linda Mar Boulevard. In this nighttime view from the 1950s, the station provided fill-ups from 6:00 a.m. to 10:00 p.m. Later, this station was torn down to make way for a Denny's restaurant, so Lou bought a Texaco station across the street that he ran with his son Dave. (Dave Nannini collection.)

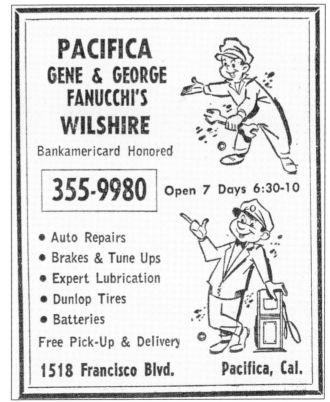

PACIFICA, WILSHIRE STATION. Brothers Gene and George Fanucchi operated a Wilshire station on Francisco Boulevard next to the local watering hole, Winters Tavern. Though the Wilshire pumps are gone, the building survived nearby freeway construction and exists today as Simon's Auto Werks. (Authors' collection.)

Tire Evolution. Technologies that were innovative 80 years ago are now things motorists take for granted, as shown in this 1947 B.F. Goodrich advertisement touting the development of tubeless tires. When a tire gets a puncture today, a quick, temporary fix is accomplished by inserting a glued plug and placing a patch over the inside to seal the plug. This time-saving repair gets the driver back on the road quickly. B.F. Goodrich was the first company to bring a radial tire to market in 1965 with its Lifesaver tire. In 1967, the company introduced the run-flat tire; in 1972, the first radial ply tires; and in 1976, the first all-terrain tire. (Authors' collection.)

Henry Ford's Influence. The Firestone Tire and Rubber Company got its start in August 1900. Six short years later, Henry Ford selected the brand to be fitted to all new production vehicles. By 1926, Firestone was operating the world's largest rubber plantations, which were located in Liberia, West Africa. In addition to tires, during World War II, Firestone converted to making artillery shells, helmet liners, and barrage balloons. During the 1950s, it also built MGM-5 Corporal surface-to-surface missiles. After a tumultuous financial decade of the 1970s, the company underwent major restructuring and cost-cutting efforts. In 1988, Firestone was sold to Japanese tire maker Bridgestone. Earlier in its history, in 1926, the company set up its Firestone Complete Auto Care car repair and tire shops with the first location opening in Nashville, Tennessee. Today, there are more than 1,700 Firestone Complete Auto Care locations across the United States. (Authors' collection.)

Tire Business Diversification. The General Tire and Rubber Co. was founded in Akron, Ohio, in 1915. During the Great Depression, General Tire and Rubber bought out two failed tire manufacturers. As business lagged in the Great Depression, the company acquired a number of Ohio radio stations, and in the 1950s, it acquired KFRC in the San Francisco Bay Area as it diversified its holdings. In 1955, the company bought Howard Hughes's RKO Radio Pictures for $25 million. Using its experience with rubber and chemical manufacturing, General Tire and Rubber formed a partnership with the Aerojet Corp. to form Aerojet-General, building solid-fuel rockets and other aerospace products. In 1984, all of the company's various divisions became subsidiaries of GenCorp. In 1987, the General Tire division was sold to Continental AG, the German tire manufacturer, and is now part of Continental Tire of North America. (Authors' collection.)

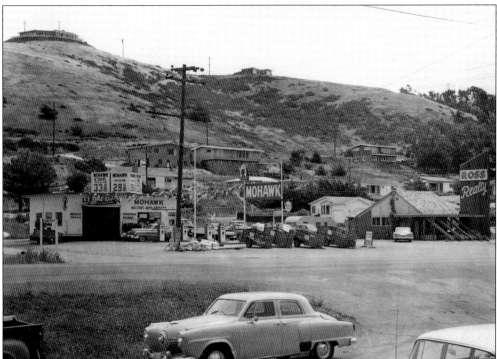

Pacifica, Mohawk Station. Hector's Mohawk Station and auto repair was a familiar sight at 133 Francisco Boulevard at the base of Gypsy Hill in the Sharp Park District. Hector's also rented trailers. The auto pictured here is a 1951 Studebaker Commander. This gas station and all other stations in the northern part of Pacifica were demolished when the Highway 1 freeway was built in the 1960s. (PHS.)

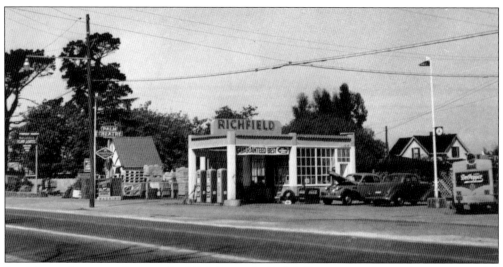

SAN MATEO, RICHFIELD SERVICE. Fred Fadelli ran the Richfield station on the northeast corner of El Camino Real and Seventeenth Avenue. The property encompassed the service station, two small stores, and a home. Fadelli sold his interest in the station following World War II. In November 1955, Safeway stores acquired the property, cleared the buildings, and constructed a large grocery store on the land that serves shoppers to this day. (SMCHA 2020-035-115.)

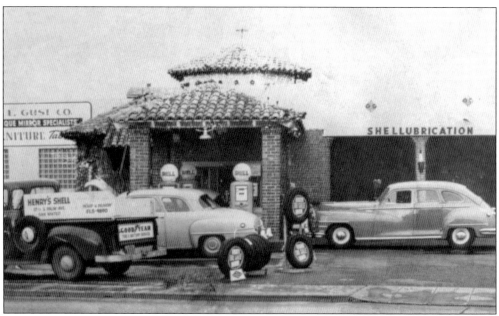

SAN MATEO, SHELL. Henry's Shell station at 1641 Palm Avenue was constructed during the Depression years as a Spanish-themed building with tile roofs, a brick facade, and a front portico. The station remains in business today as Bob Reed's Auto Service and has been a mainstay in San Mateo's Hayward Park neighborhood for nearly 90 years. The station specializes in brake repairs, oil changes, and tires and pumps Olympian gasoline. (Bob Reed collection.)

SAN MATEO, UNION 76. This traditional-styled, postwar Union 76 station was once located on El Camino Real at Borel Avenue. This design was common to the 1950s stations built by the Union Oil Company of California. The design was simple, and the large canopy over the pumps provided protection from the weather. A Union 76 station with a more contemporary look continues to operate at this same location in 2025 after more than 70 years. (SMCHA 2020-035-117.)

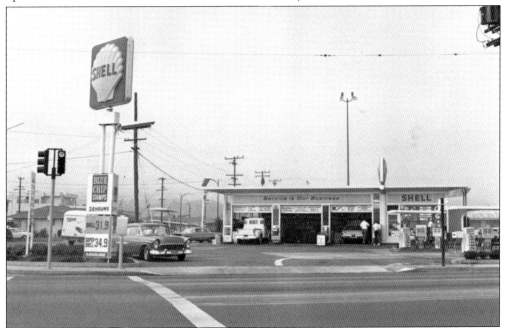

SAN MATEO, STATION CHANGES. This image shows Conn Ward's Shell service station as seen on October 9, 1964. The station was located on El Camino Real and Twentieth Avenue, just down the street from the then under-construction Highway 92. There is a modified 1955 Chevy for sale, with a 1960 Buick and 1953 Chevy truck in the service bays. This is the same station as shown on the book's cover, only a few years later. Notice the upgraded pumps. (SMCHA 2015.001.06094, Norton Pearl Collection.)

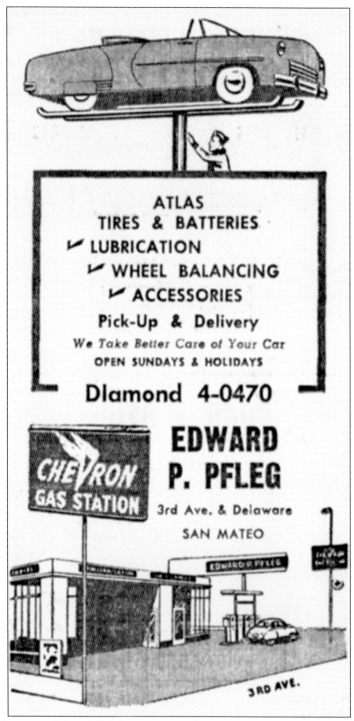

SAN MATEO CHEVRON. Edward P. Pfleg was once the proprietor of a Chevron station at Third Avenue and South Delaware Street in San Mateo. He shared the busy intersection with Fred and Gene's Shell service and one other gas station. An Arco station continues to pump gasoline today at the former Chevron site. (Authors' collection.)

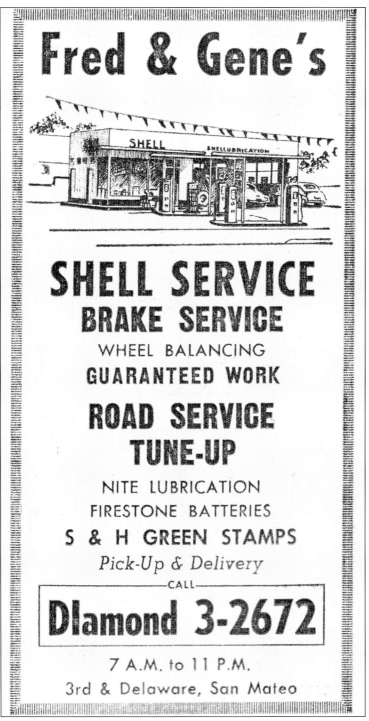

SAN MATEO, GAS AT THE CROSSROADS. Third Avenue and South Delaware Street has always been a popular area for service stations due to its proximity to the downtown and nearby Bayshore Highway. Fred and Gene's Shell service shared the corner with two other stations, including a Chevron dealer. A modern Shell station remains at that same location in 2025. (Authors' collection.)

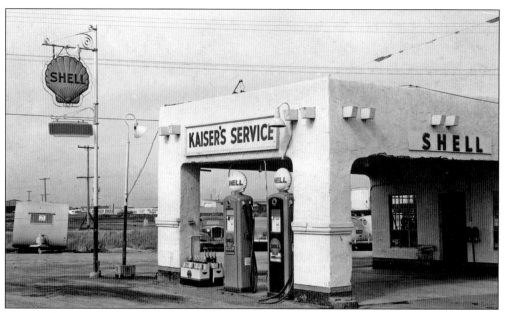

EARLY SAN MATEO SHELL. The Shell station at Nineteenth Avenue and Bayshore Highway was owned by Henry E. Mitvalkey, who also owned the adjacent Henry's Garage. Mitvalkey's relative, last name Kaiser, ran the service station, which opened in 1931, when the Bayshore Highway opened as well. The service station island is fitted with Bennett 646 pumps with seashell globes. The area under the awning is concrete while the area outside is gravel. (SMCHA 2020.035.113-10401.)

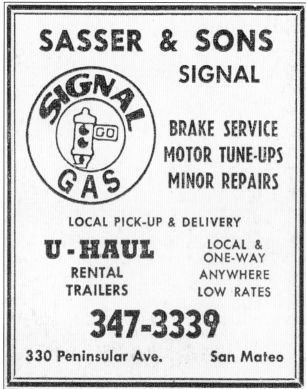

SAN MATEO SIGNAL STATION. Signal Oil was big in seven western states from the mid-1920s to 1964. Sasser Signal was one of the many Signal Oil dealers in the San Francisco Bay Area. In 1974, Signal Oil was sold to the Burmah Oil Company, and the brand was discontinued. The name Signal Oil Company was revived recently to provide export shipments of Russian oil. The company has no affiliation with the Signal Oil of yesteryear. (Authors' collection.)

SAN MATEO SERVICE. This Signal station once stood on the corner of El Camino Real and Hobart Avenue. Proprietor Harry Lee advertised "highest octane gas" and had a small garage behind the station where he specialized in tire and minor auto repairs. Signal Oil Company was founded in 1922 by Samuel Mosher in Signal Hill, California. Its striking red, black, and yellow signs surrounding a traffic signal were well-known throughout the Western states. (SMCHA 2020-035-117-17355.)

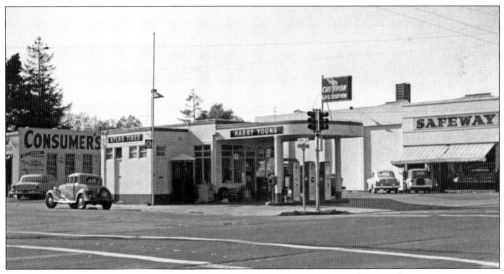

SAN MATEO COMPETITION. Across Hobart Avenue from Harry Lee's Signal station was Harry Young's Chevron station. This small, neighborhood, three-pump Chevron station was independently owned, whereas the parent company Standard stations were owned by the Standard Oil Corporation. Today, the Chevron station is gone, replaced by a parking lot for the Cororan Global Living Company. (SMCHA 2020-035-118-17354.)

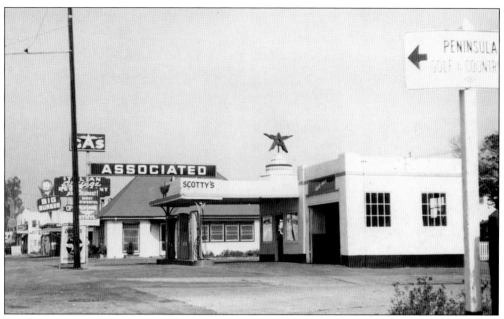

SAN MATEO FLYING A. Associated's Flying A brand was very popular with most cities having two or more of the stations, each varying in the amount of architectural features. Scotty's Flying A on El Camino Real was built with the "wedding cake" feature with the Flying A symbol on top of the office. The pole sign at the street side of the property not only holds up the horizontal Associated sign, but also advertises Flying A Ethyl. Farther south in town was the Hillsdale Flying A station on Pacific Boulevard, which paralleled the Southern Pacific train tracks near Hillsdale Mall. Pacific Boulevard changes its name to Old County Road at the San Mateo/Belmont border. The Italian Village Restaurant and "19¢ Big Burger" can be seen in the distance. (Above, SMCHA 2020-035-116-17383; below, authors' collection.)

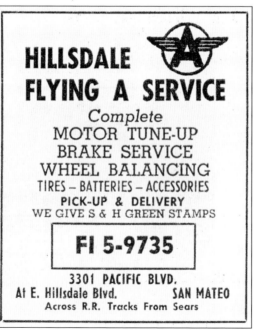

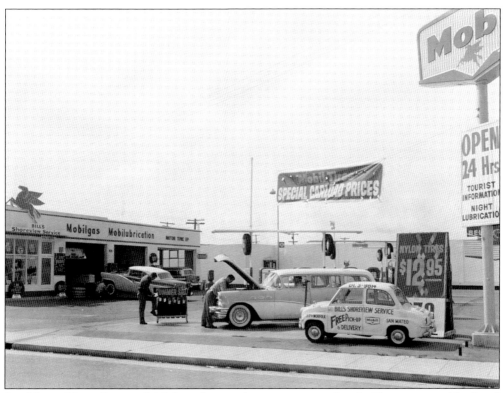

SAN MATEO MOBIL SERVICE. Mobil gasoline products were pumped in the Shoreview neighborhood at Bill's on the corner of East Third Avenue and South Norfolk Street. Proprietor Bill Squire was offering complimentary pick-up and drop-off using a German-made Goggomobil mini-car. Receiving attention is a 1956 Chevy in the first bay, a 1956 Ford getting a new left front tire, a 1956 Ford wagon in the last bay, and a 1956 Buick station wagon with its hood up. (SMCHA Norton Pearl Collection, 2015-001-01328.)

SAN MATEO CORNERS. The intersection of Third Avenue and El Camino Real is seen in 1962 from the Chevron station on the southeast corner and looks at the Associated Flying A station as well as the Mobil station on the northwest corner. The street-facing banner offers motorists a "Free 49ers Schedule" and promotes the game on radio and television. Note the smartly uniformed attendant pumping gas from a Tokheim pump. (SMCHA 2015-001-03557-24.)

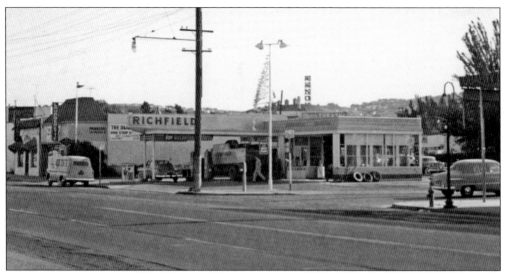

SAN MATEO, RICHFIELD SERVICE. The Richfield Oil Co. began in Los Angeles in 1905. In 1966, the company merged with the Atlantic Refining Co. to form the Atlantic Richfield Company, later renamed ARCO. This attractive station, located at Twenty-third Avenue and El Camino Real, was typical in style of the many Richfield establishments throughout the West. Today at this location, a Beacon gas station has replaced the old 1950s Richfield facility. (SMCHA 2020-035-118-17404.)

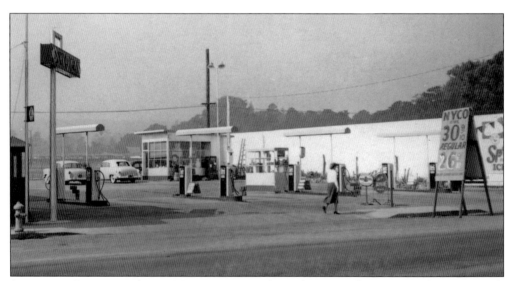

SAN MATEO GAS WARS. The NYCO gas station was located at 1940 El Camino Real at Nineteenth Avenue. Operated by Clifton Nye, the station was often engaged in price wars with competitors along El Camino Real. In July 1960, the NYCO station was offering regular gas for 19.9¢ and ethyl for 25.9¢, 3¢ a gallon cheaper than his nearest discount competitor and 12¢ less than the major brand stations. (SMCHA 2020-035-116-17375.)

SAN MATEO DOWNTOWN. In the heart of downtown, Ray Toynton served motorists for many years at his service station at Fourth Avenue and B Street. Ray's Texaco was a convenient drop-off location for customers shopping at nearby Levy Brothers, Joseph Magnin's, City of Paris, Talbot's Toys, and other fine downtown stores. (Authors' collection.)

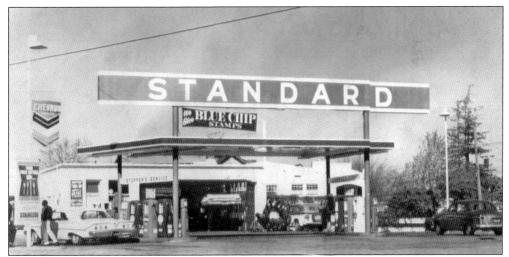

SAN MATEO CUSTOMER SERVICE. Len Stopper's Standard station was located at 610 North El Camino Real, and Stopper himself can be seen next to the Chevrolet convertible at left. The Stopper family Jeepster is parked at the rear of the lot. At the end of each island is an Eco Tiremeter for topping off air pressure. Stopper was always the marketeer, and the promotions he ran made for a good repeat business. (Courtesy Dennis Stopper.)

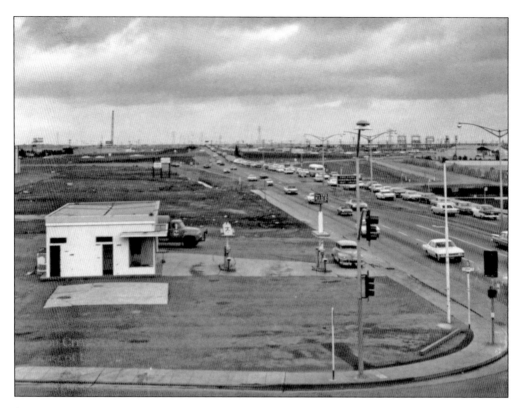

SAN MATEO, HIGHWAY 92. Progress put an end to the General Petroleum/Mobilgas station on Nineteenth Avenue and Phillips Drive in preparation for the construction of State Route 92. The station has been prepared for demolition, but interestingly enough, the cash boxes and credit card machines are still extant at the pump islands. Behind the station was a Unimart store, which was one of a chain of 15 big-box discount retailers that sold everything from groceries to televisions and air conditioners. (Above, San Mateo County Library; below, SMCHA 2020-035-126-24198.)

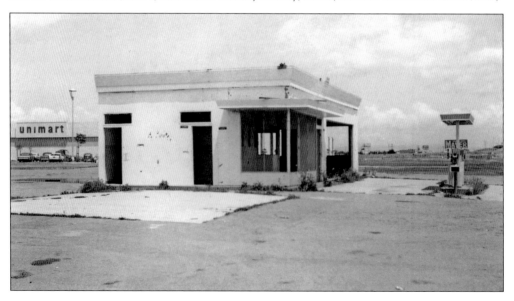

SAN MATEO, CHEVRON. In 1967, the Nineteenth Avenue Freeway alignment of State Route 92 was completed, essentially bypassing the surface streets, which included the corner of Nineteenth Avenue, South Grant Street, and Ginniver Street. On the southeast corner sat a Chevron station with the adjoining shopping center to the south. The shopping center with its low-sloping roofline is still there; however, the service station has been replaced by a three-story apartment complex. (SMCHA 2020-0350129-24196.)

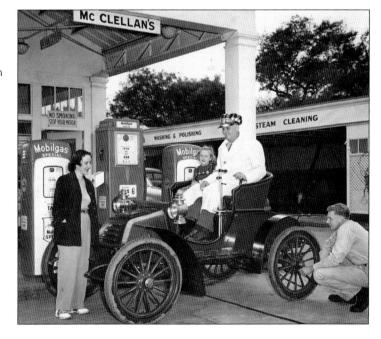

SAN MATEO, RARE RUNABOUT. McClellan's Mobilgas station at Baldwin Avenue and San Mateo Drive was once a mainstay of downtown. In December 1950, longtime customer R.H. Berg of Hillsborough visited the station with his family in his restored 1904 Autocar Runabout. Three gas pumps are seen under the canopy; two Martin and Schwartz model 80 "script top" pumps surround an older Mobilgas Special Tokheim 36B. (Authors' collection.)

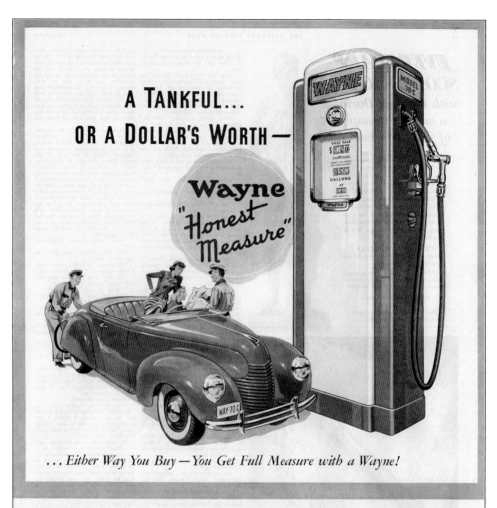

WAYNE GAS PUMPS. It took a while for the motoring public to trust the accuracy of a gas pump as well as the station operators. Visible pumps went a long way to securing that trust, but the dispensing process was slow. California's Gasoline and Oil Substitution Act of 1931 set standards for petroleum weights and measures and gave the state's Division of Weights and Measures authority to enforce those standards. With the public now confident in the state's ability to ensure the customers were getting what they were paying for, computerized pumps came on the market, which measured the amount of fuel being dispensed, later followed by calculating pumps that also computed the value of the fuel. The slogan "Wayne: Honest Measure" is seen in this 1940 Wayne Pump Co. advertisement designed to reinforce its commitment to accuracy with the general public. (Authors' collection.)

Three

SOUTH COUNTY
EAST PALO ALTO, LA HONDA, MENLO PARK, PORTOLA VALLEY, REDWOOD CITY, SAN CARLOS, AND WOODSIDE

Today, gas stations gather at freeway off-ramps. This was not the case prior to the construction of freeways in the 1950s and 1960s. The Bayshore Highway, completed as far as Menlo Park and East Palo Alto in 1932, was a four-lane, undivided boulevard with businesses fronting directly on the roadway. Motorists simply turned off the pavement to get to gas stations, motels, grocery stores, and restaurants. Such was the case with these two cities. Both towns had numerous stations along the highway. The small unincorporated community of East Palo Alto, for example, was once home to 11 gas stations.

With the increase in automobiles and improved roads, Redwood City, the county seat, also became the site of many gas stations. In 1931, the Bayshore Highway reached Jefferson Avenue, resulting in numerous stations opening along the new highway and at notable intersections in the city.

On the north side of Redwood City, San Carlos had a similar pattern of growth. Several gas stations and garages were built at key points in the city once El Camino Real reached the town in 1920. The earliest stations included a General Petroleum station, which was built at El Camino Real and Cypress Street (later renamed San Carlos Avenue), and the San Carlos Garage was constructed at Holly Street and El Camino Real.

To the south of Redwood City, in the leafy town of Atherton, only one gas station was ever built—a Standard station at El Camino Real and Almendral Avenue. Due to Atherton's prohibition of all businesses, this station was torn down in the 1970s.

Farther west in the county, the towns of Half Moon Bay, La Honda, Pescadero, Portola Valley, San Gregorio, Sky Londa, and Woodside were dotted with stations to service the residents and farms of the rural valleys and coastal mountains of San Mateo County.

Retail gasoline operations in the county have mirrored the growth of motorists from the 1920s to the first decades of the new millennium. In 2019, the State of California estimated there were more than 790,000 cars, trucks, trailers, and motorcycles registered in the county.

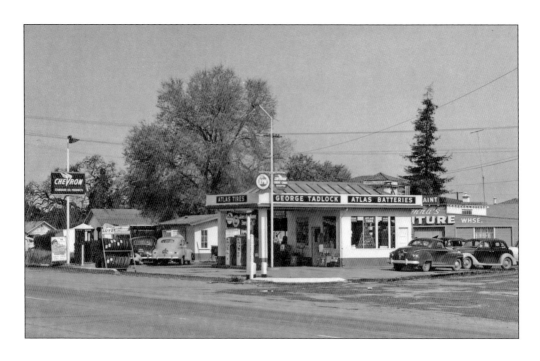

EAST PALO ALTO. George Tadlock bought the Chevron station at 1541 Bayshore Highway in August 1952. It had previously been owned and operated by John and Ernest Oller. Oller lived a few doors down from Tadlock on Camellia Drive in East Palo Alto. Business was good along the highway that connected San Francisco and San Jose, as one vehicle is being worked on outside the service bay while others wait their turn in the lot. In the photograph below, notice that the street signs are white poles placed at the corner, which are extremely hard to read at speed, in the dark, or in bad weather. Tadlock's station was demolished to make way for Highway 101. With the service station gone, Tadlock continued to operate his auto supply store at 645 Donahoe Street, also in East Palo Alto. (Above, SMCHA 2020-035-019-10626; below, -022-10626.)

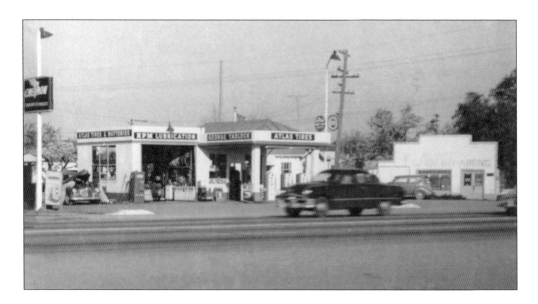

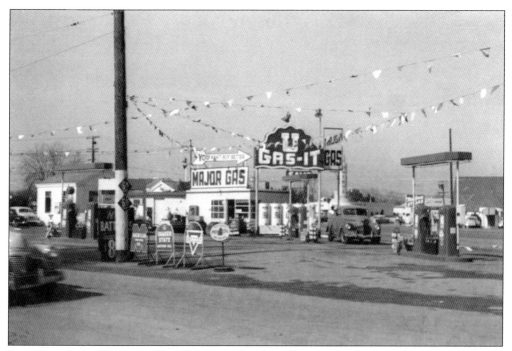

EAST PALO ALTO, DISCOUNT GAS. Before the Bayshore Freeway was built in the 1950s, many gas stations fronted directly on the four-lane Bayshore Highway (US 101 Bypass). Such was the case for the U-Gas-It station, an independent dealer, at 2000 University Avenue. U-Gas-It was owned by Ethen's Inc., who, in addition to the gas station, owned a nearby bar. This business was one of 11 gas stations in tiny East Palo Alto. (SMCHA 2020-035-020-10600.)

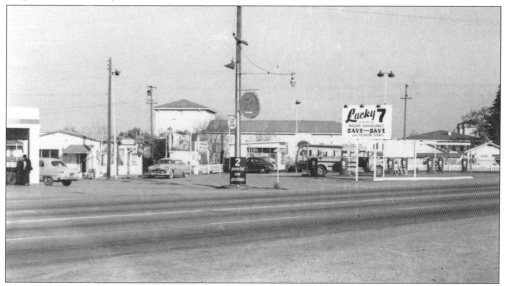

EAST PALO ALTO, LUCKY 7. Several blocks north of the U-Gas-It station, the Lucky 7 gas station stood on the corner of Glen Way and Bayshore Highway. The property sported seven gas pumps (hence the name) and was owned by Mary Kohler. The station offered "major gasoline" at discount prices, 3¢ to 5¢ cheaper than name brands. This station was demolished in 1957 when the new Bayshore Freeway was built. (SMCHA 2020-035-022-11439.)

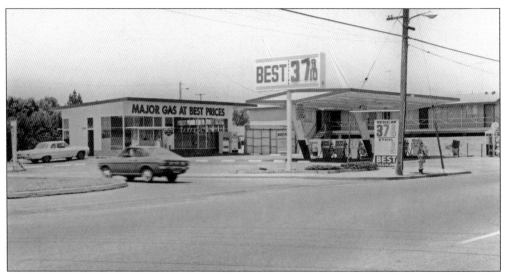

MENLO PARK, BARGAIN GAS. Gulf Oil operated a number of budget, self-serve stations under the Best Gasoline brand. This station was located on the northwest corner of Bayshore Highway and Willow Road. The station was owned by Ted Orden. Notice that the service bays are closed and the pumps are self-service in this photograph from 1974. (SMCHA 2020-035-028.)

EAST PALO ALTO, HANCOCK STATION. Located on the corner of Bayshore Highway (US 101 Bypass) and Dumbarton Avenue was this compact Hancock gas station and tavern. The station and bar were owned by Antonio and Luigia Reginato. Above the bar was a two-room apartment. This photograph was taken in the early 1950s before the Bayshore Freeway was built. Both buildings were demolished to make way for the new freeway in 1957. (SMCHA 2020-035-022-11465.)

76

LA HONDA. Located in the Santa Cruz Mountains, halfway between the busy peninsula cities and the Pacific Ocean, on the La Honda-San Gregorio Road (now State Route 84), lies tiny La Honda. These two views of the same building show a Red Crown station in 1930, while the second image from 1937 depicts a Shell station. It was common in the past for gas stations to switch brands periodically in order to gain better prices. While the earlier Red Crown station operated with one gas pump, the newer Shell station gained a second pump, an AAA repair garage, and towing. (Rob and Kathy [Zanone] Wolf via Bob Dougherty.)

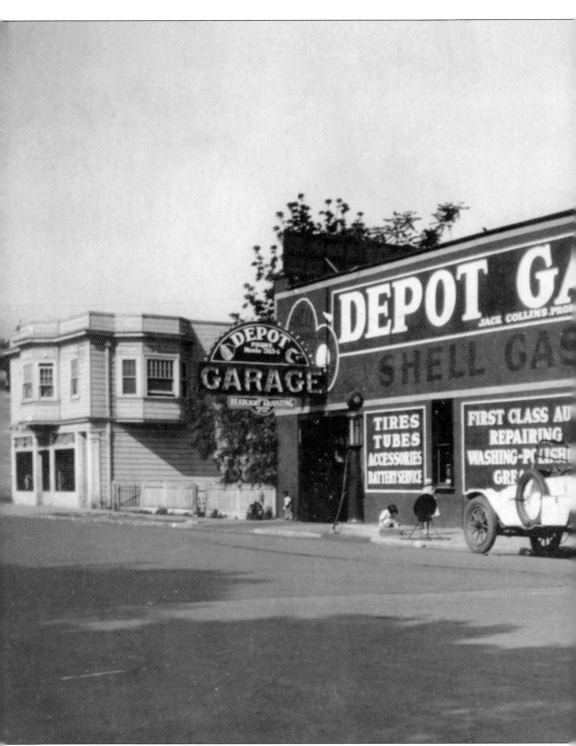

MENLO PARK, 1920s SERVICE. The Depot Garage was an appropriately named building as it was located on Santa Cruz Avenue at Merrill Street across from the Southern Pacific train station. This garage provided Shell gasoline through a single visible pump in addition to "first class auto

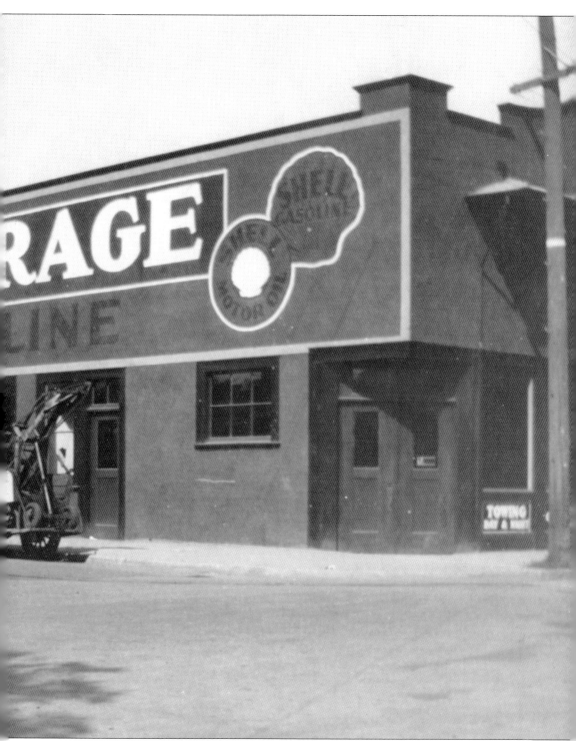

repairing," washing, greasing, and tire service. This convenient location allowed commuters to drop off their cars in the morning and pick them up at night. This 1920s image also shows the garage's primitive tow truck, likely converted from an old sedan. (MPHA.)

MENLO PARK, SHELL STATION. Photographed in the early 1930s, this Shell station on the corner of Santa Cruz Avenue and El Camino Real was one of hundreds of prefabricated metal and glass stations erected by Shell beginning in 1915. These simple but sturdy structures were assembled by Shell workers in less than a week for a cost of $2,200. The automobile seen in this photograph is a 1925 Essex Coach built by Hudson. (MPHA.)

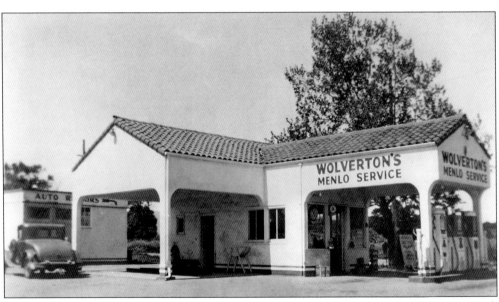

MENLO PARK GAS. Wolverton's Menlo Service station opened in 1926 along the El Camino Real; however, it did not survive the Great Depression. The station closed shortly before America's entry into World War II. At the time, the station had modern, computing gas pumps and a service garage at the rear of the property. Notice the crescent-shaped water trough under the window used to check for leaks in tire tubes. (MPHA.)

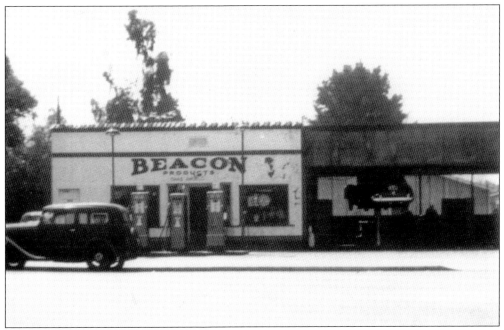

MENLO PARK, BEACON STATION. The Beacon Oil Co. was founded in 1919 in Everett, Massachusetts. After acquiring several smaller oil companies, Beacon itself was acquired by Standard Oil of New Jersey and later by Valero Corp. The company had numerous stations on the East Coast under the name Colonial Beacon. In the 1940s, this station stood on El Camino Real at Partridge Avenue and was equipped with three modern Bowser 575 pumps. (MPHA.)

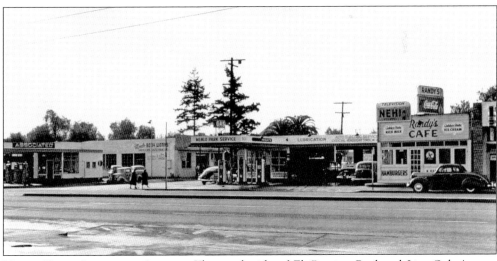

MENLO PARK, ASSOCIATED STATION. The south side of El Camino Real and Live Oak Avenue featured one of the city's two Associated service stations, with Menlo Park service across the street at 901 El Camino Real. Both stations sold gas and made repairs, and with Menlo Body Works one door west on Live Oak Avenue, made this intersection a one-stop shop for car owners. (MPHA.)

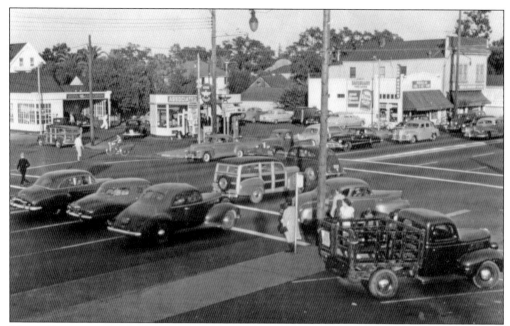

MENLO PARK, FLYING A. Associated Service Station No. 522 awaits customers in this 1950 image of a congested El Camino Real and Oak Grove Avenue. The need for a signal is apparent as cars, bicycles, and pedestrians compete for space at the busy intersection. Pictured are three somewhat rare wooden station wagons—two Fords and a Plymouth. "Woodies," as they are known today, were the SUVs of yesteryear, aptly hauling kids and cargo alike. (MPHA.)

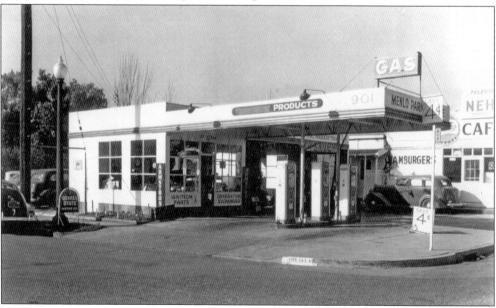

INDEPENDENT STATION. Menlo Park Service, 901 El Camino Real at Live Oak Avenue, was an independent oil dealer pumping discount gasoline 4¢ per gallon cheaper than other stations. They also provided auto repairs, tire service, oil changes, and greasing. Previously, Menlo Service was owned by a Signal Gas and Oil distributer. Signal, founded in 1922 in Los Angeles, had many stations throughout the seven Western states. (MPHA.)

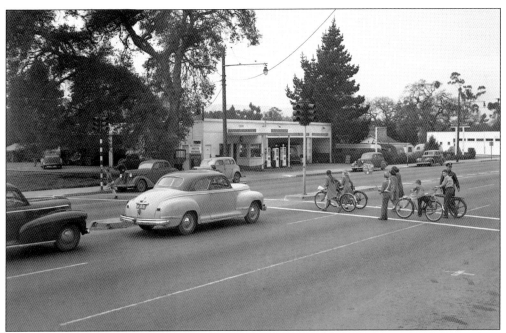

MENLO PARK, STREET SAFETY. The safety of schoolchildren was paramount in this image from March 3, 1947. A school crossing guard and a police officer safely guide the kids crossing a wide and busy El Camino Real south of Valparaiso Avenue near Central School. In the background stands a three-pump Union 76 service station and repair garage. (Reg McGovern collection.)

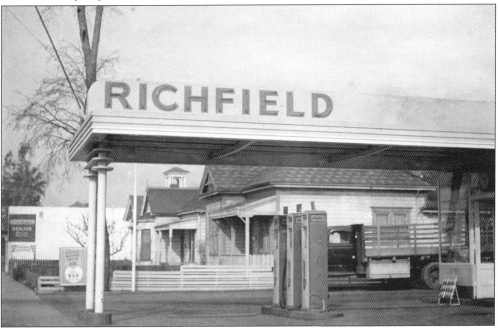

MENLO PARK, RICHFIELD. The Richfield station on the corner of Oak Grove Avenue and El Camino Real had some Art Deco architectural features and a large neon sign built into the canopy. Notice the tire pressure air hose is mounted underground at the end of the island to enable station attendants to check the tire pressures of vehicles on both sides of the pump island. (MPHA.)

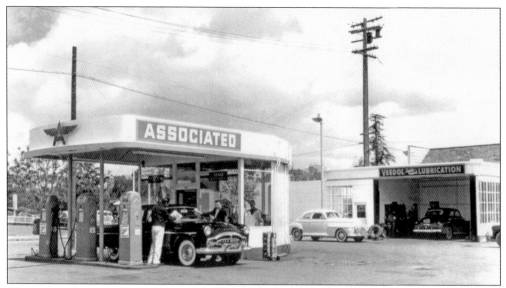

MENLO PARK, NATIONAL PUMPS. Associated attendants are busy cleaning the windshield of this shiny new 1952 Packard sedan. This station was one of several Flying A stations in Menlo Park but was more modest in design compared to other Associated stations in the area. It was smaller and lacked decorative touches like a topper and Flying A logo on the roof. Three beautiful, porcelain, Streamline Moderne–styled A-38 National pumps are visible on the pump island. (MPHA.)

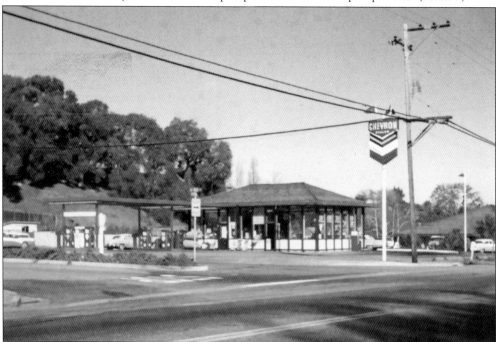

PORTOLA VALLEY CHEVRON. This attractive Chevron station was once located at Alpine Road and La Mesa Drive in Ladera. The pleasingly styled station, with a low-peaked shingled roof, befits the architecture of this planned, mostly residential cooperative community begun in 1945. Ladera was designed by noted landscape architect Garrett Eckbow, and many of the homes and structures were created by Joseph Allen Stein and John Funk. (Portola Valley Historic Resources Committee.)

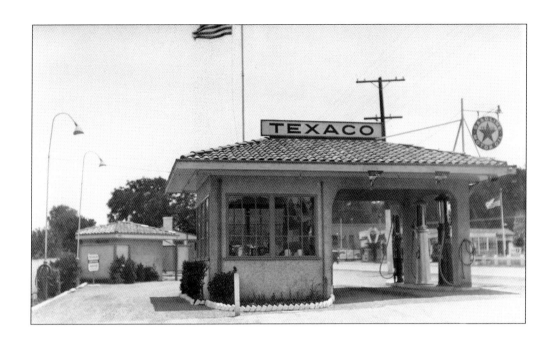

REDWOOD CITY, EARLY TEXACO STATION. Pictured here are north and south views of a Bay Area Texaco station with architecture similar to the station that was located at El Camino Real and James Avenue. Like many stations of the era, a separate restroom building was provided for motorists. Two visible pumps are located under the canopy with the outside lane very close to the street to accommodate oversize vehicles. After World War II, the Texaco at El Camino Real and James Avenue was owned by a gentleman named McGee, and between 1950 and 1951, the station was purchased by brothers Bill and Tony Bolich. By 1955, Tony left the partnership, and Bill ran the station until late in 1970. Ownership passed through a number of owners until it was torn down to make room for the Sequoia Station shopping center in 1991–1992. (Both, LHR-RWCPL.)

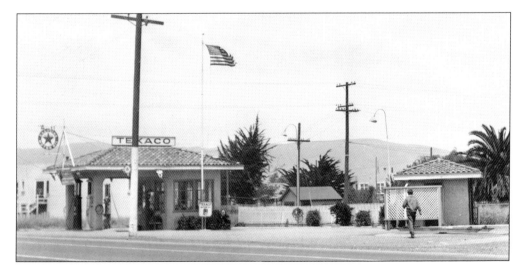

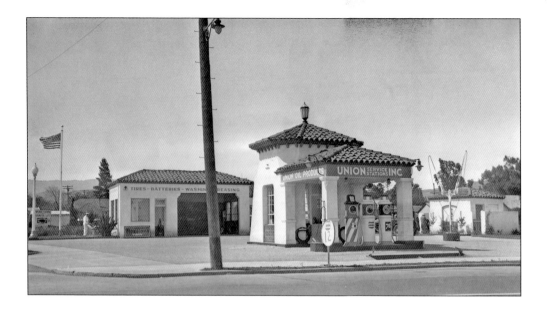

REDWOOD CITY, UNION SERVICE. The Union station at the corner of El Camino Real and Avondale Avenue was built in a Spanish-style motif with terra-cotta clay roofing tiles. The service island featured three Tokheim clockface gas pumps. The service bay building at the rear of the station could accommodate two cars and had a small maintenance office. Note the attendant watering the lawn near the office. A separate restroom building surrounded by well-manicured grounds was located on the west side of the property. The station sold Firestone tires, and samples can be seen under the canopy near the station office. (Both, LHR-RWCPL.)

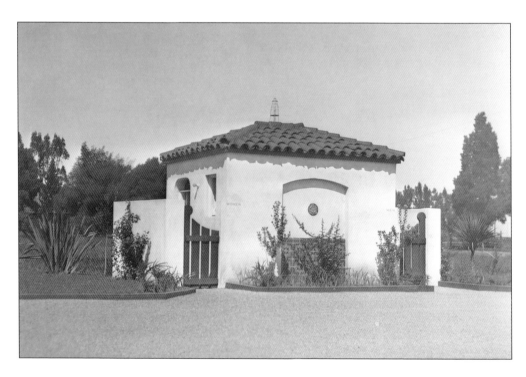

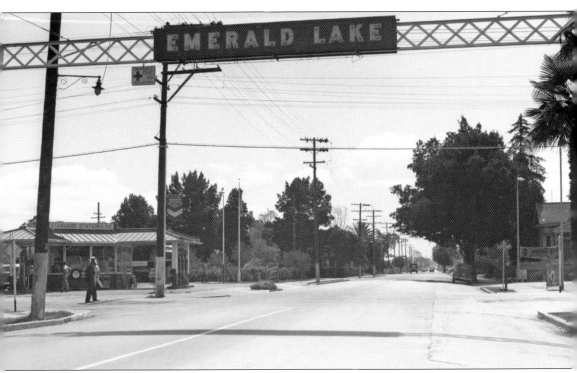

REDWOOD CITY, EMERALD LAKE. Jefferson Avenue and El Camino Real was the location of this early Standard station. In this 1936 view looking south, the distinctive Emerald Lake Arch and neon arrow can be seen directing motorists west on Jefferson Avenue to the hillside lake and housing development, first conceived and built in the 1920s. The design of this station was common throughout California: a steel-roofed structure with abundant canopies, a centrally located office, and a bay to the rear for automobile repairs. This location remained a gas station for many years but is now occupied by a Papa John's Pizza restaurant. (LHR-RWCPL.)

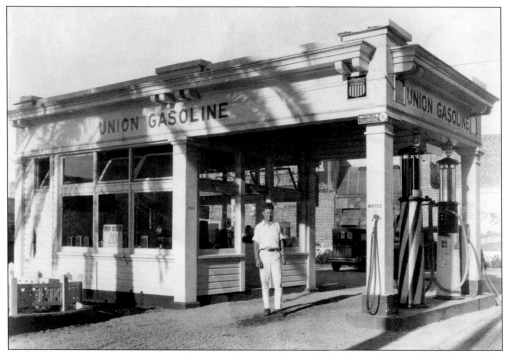

REDWOOD CITY, BOYLE-DAYTON PUMPS. Ernest Bean stands in front of his Union Service station on the corner of Broadway and El Camino Real in 1929. The Boyle-Dayton 10-gallon visible pump at the right dispensed regular gas. The visible pump at left is a Boyle-Dayton 83 and dispensed Union Ethyl. These pumps were overall white with a blue top and base paired with blue vertical stripes that twisted around the pump's body, making it look like a lighthouse. (LHR-RWCPL.)

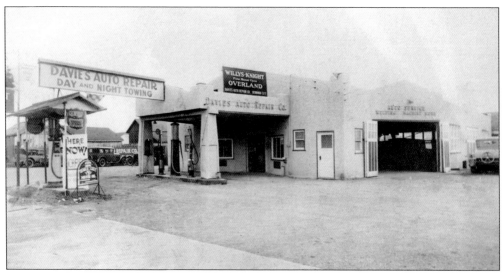

REDWOOD CITY, DAVIES FAMILY. Nelson Davies opened Davies Auto Repair on the corner of El Camino Real and Vera Avenue in 1916. Seven years later, Davies brothers Albert and Thomas took over the business and began selling Willys-Knight Overland vehicles. Notice the visible gas pump with two pre-1920s pumps on either side. (Reg McGovern.)

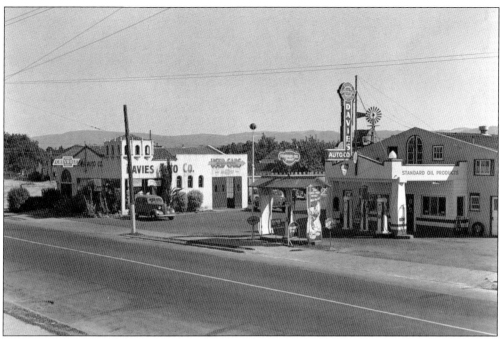

DAVIES OPERATIONS EXPAND. In the early 1930s, the Davies brothers branched out into Chevrolet sales and service as well as selling Standard Oil's line of gasoline and lubricants. In 1942, Chevrolet sales and service moved into a spacious new dealership on the corner of El Camino Real and Jefferson Avenue, while the Vera Avenue property was converted to appliance sales. The Davies family sold the car dealership in 1990. At the time, it was the oldest family-owned Chevrolet dealership in Northern California. (Above, LHR-RWCPL; below, Reg McGovern.)

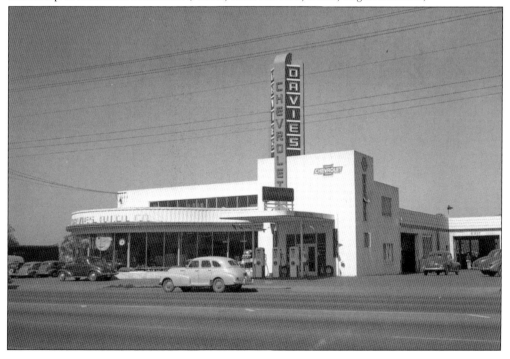

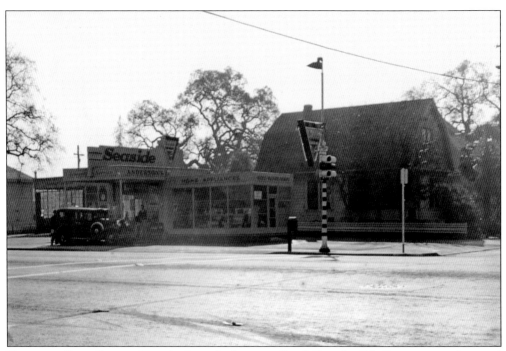

REDWOOD CITY, SEASIDE OIL. Anderson's Service offered Seaside Oil Company gasoline and Firestone tires, and customers had the opportunity to shop for new home appliances while their cars were being serviced. Located on the corner of El Camino Real and Jefferson Avenue beginning in 1936, it also offered drive-in sales and service for car and home radios. By the mid-1950s, the service part of Anderson's was separated with the Seaside-branded gas pumps out front with radio repairs in a new building seen at left. The station was later remodeled into an appliance showroom. Of note, Seaside Oil Company was one of the first major oil companies to introduce credit cards. Anderson's stopped selling gasoline and moved its appliance business to 901 El Camino Real. The company ceased operations in 2009 after more than 70 years in operation. (Above, LHR-RWCPL; below, Reg McGovern.)

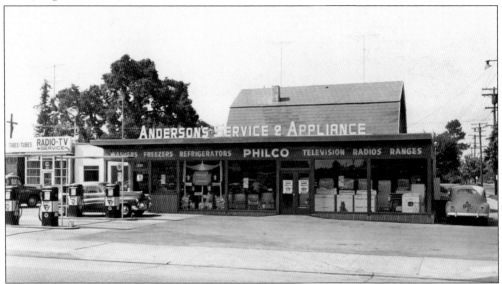

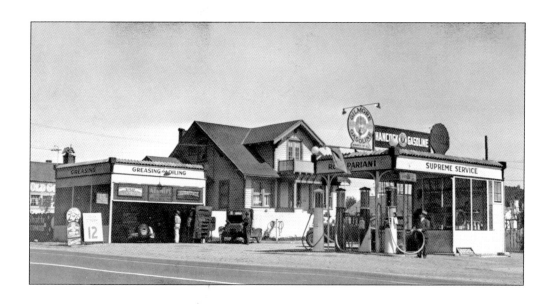

REDWOOD CITY, HANCOCK STATION. The corner of El Camino Real and Hopkins Avenue began as a Hancock Gasoline station, owned and operated by Ron Pariani. The station at 600 El Camino Real also sold Shell, Gilmore, and Green Streak gasoline through visible pumps. Two service bays catered to the mechanical needs of local automobile owners. In the center window, the tops of four oil "lubesters" used to dispense bulk motor oil into quart jars can be seen. Today, this location is a Circle K gas and market. This late-1910s or early-1920s photograph shows the Vienna Inn and looks south on El Camino Real. (Both, LHR-RWCPL.)

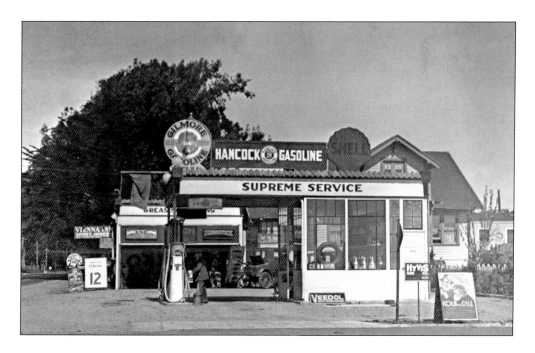

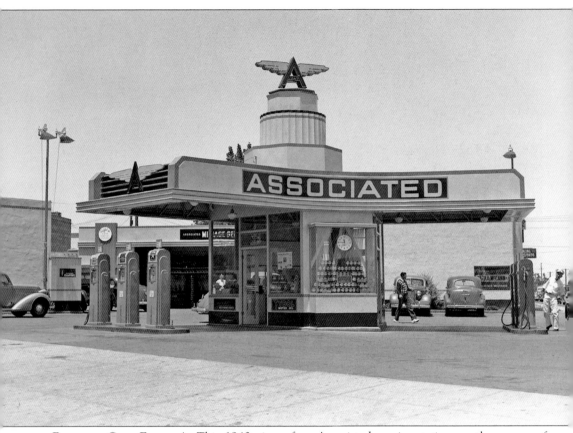

REDWOOD CITY, FLYING A. This 1940 view of an Associated service station on the corner of Broadway and El Camino Real across from Sequoia High School featured an attractive Streamline Moderne style of architecture popular in the 1930s and 1940s. Inspired by aerodynamic design, Streamline Moderne emphasized curving forms and long horizontal lines. The six National A-38 gas pumps complimented the curved roof lines, "wedding cake topper," and Flying A winged logos. This station was once owned by Gee L. Turner. When the station was removed, the property was converted for retail banking. (Reg McGovern.)

REDWOOD CITY, TWO VIEWS OF BROADWAY. Shot from the corner of Arguello Street and Broadway at the train tracks looking west toward Sequoia High School, a Standard station can be seen at the left, and a Shell station is receiving a delivery at the right. Notice the tanker truck under the Shell station canopy and the undeveloped hillside in the distance. Below, the busy intersection of Broadway and El Camino Real, pictured in 1939, was home to a Union Oil station. The Redwood City Courthouse dome can be seen in the background, and notice that the traffic signals have been painted with alternating stripes to help motorists see the lights. (Both, Reg McGovern.)

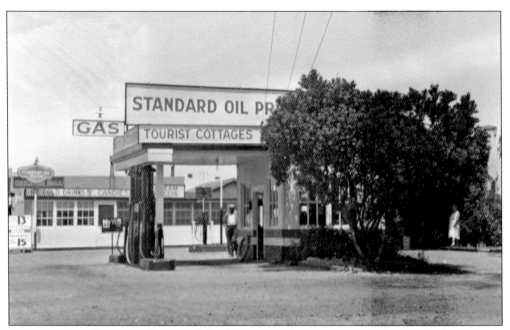

REDWOOD CITY, STANDARD STATION. John Moore was the proprietor of the Standard station on the corner of El Camino Real and Buckingham Avenue when this photograph was taken in the mid-1930s. Notice the trio of visible pumps at the island and that the canopy only covers the inside lane. This gives the station the flexibility to accommodate oversized vehicles. Conveniently located next door is a small shop and lunch counter. (LHR-RWCPL.)

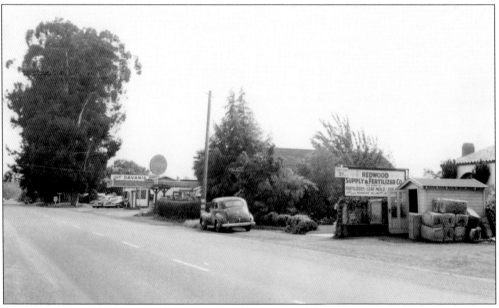

REDWOOD CITY, DAVANIS AUTO REPAIR. Katie and Gus Davanis owned the Five Points Café and Hotel at 2015 El Camino Real in Redwood City as well as Gus Davanis Auto Repair at 762 Woodside Road. This c. 1948 photograph shows a 1941 Packard 110 by the phone pole in front of Redwood Fertilizer and Supply at 703–740 Woodside Road as well as a gaggle of cars parked at the Woodside Lodge just beyond the gas station. (LHR-RWCPL.)

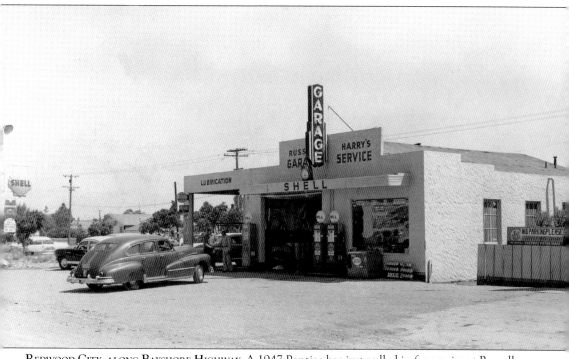

REDWOOD CITY, ALONG BAYSHORE HIGHWAY. A 1947 Pontiac has just pulled in for service at Russell and Harry's Garage and Shell service station. A recently completed 1953 Kaiser sits at the side of the lot after service as the station attendant, possibly proprietor Carl F. Russell himself, gets the keys to another auto. Russell and Harry's was located at 3158 Bayshore Highway. The Russell family made their home in a house on the back of the property, and the area to the right with the "No Parking Please" sign was the home's front yard. When Highway 101 was built through the area, the address of Russ and Harry's Garage was changed to 3158 Rolison Road. Three Shell-branded pumps dispense different grades of gasoline, and the advertising globes on top of the pumps were glass in the shape of a seashell. The former service station building still stands, and the facade, although changed, still shows the lines of the late-1940s/early-1950s gas station. (LHR-RWCPL.)

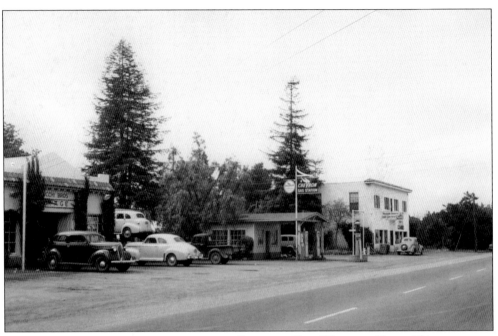

REDWOOD CITY, WOODSIDE ROAD. This prewar photograph shows the Delucchi Brothers Garage, which was located at 710 Woodside Road with an adjoining Chevron station and Woodside Grocery. Notice the visible pump at the street side and a pair of computing pumps under the awning. Cars visible are, from left to right, a 1937 Plymouth, a 1939 Chevrolet (up on the rack), a 1941 Chevy Coupe, a pick-up truck, and a 1935 Ford at the grocery. (LHR-RWCPL.)

ROOSEVELT PLAZA. On the west side of town, Carl and Ray's has been serving customers at Roosevelt Plaza for years. Later, Carl bought out Ray's interest in the station, and it operated as Carl's Shell for years. The station remains and continues to offer Shell gasoline to this day. (LHR-RWCPL.)

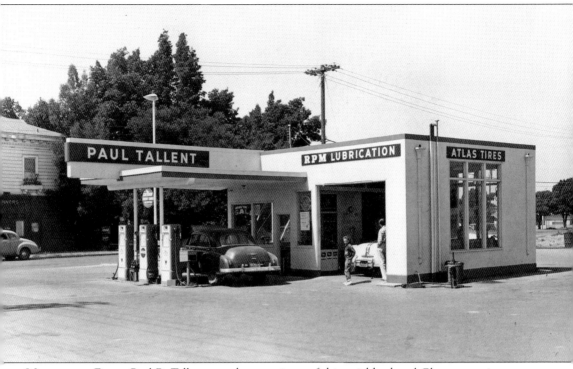

MIDDLEFIELD ROAD. Paul R. Tallent was the proprietor of this neighborhood Chevron station on the corner of Middlefield Road and Charter Street. This small station featured an office and lube room for oil changes, Atlas tire installations, and "RPM Lubrication." All Chevron stations were independently owned and were required to use only Standard Oil products, the parent company. Today, this once-quiet corner is home to Tacos El Grullense Mexican restaurant and Sigonia's Farmers Market. Across Middlefield Road is the giant Costco Wholesale store. (LHR-RWCPL.)

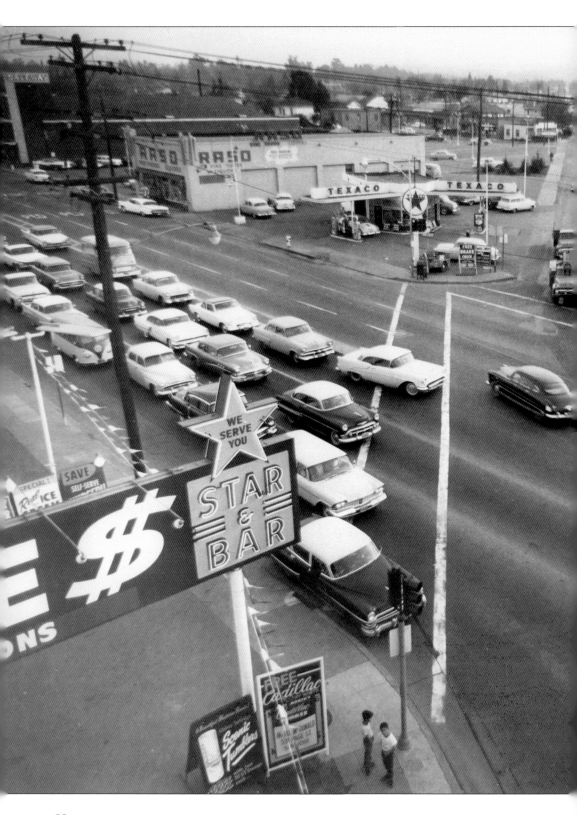

FIVE POINTS, REDWOOD CITY. The Star & Bar discount station at the Five Points intersection was one of four gas stations on this busy corner seen in this 1958 photograph. A large Texaco station is present on the opposite corner of El Camino Real and Woodside Road. Not seen is Union 76 station No. 2135 on the corner of Redwood Avenue and El Camino Real and a Shell station at Main Street and El Camino Real. At the Star & Bar, customers received coupons with their gasoline purchases that were redeemable for gifts in the office. This dangerous intersection and all three gas stations were eliminated in the early 1960s with the construction of the Woodside Road overpass. (Reg McGovern.)

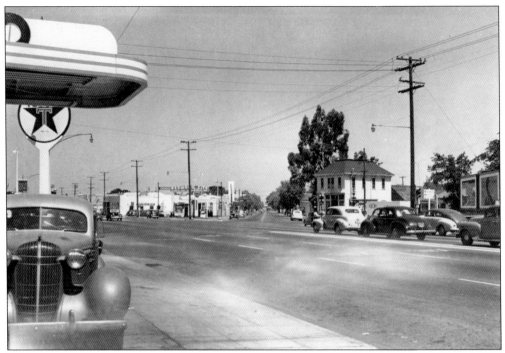

MORE FIVE POINTS. This late-1940s view of the Five Points intersection from street level shows the Texaco station in the foreground and the Shell station across the street on the corner of Main Street and El Camino Real, with the Redwood City sign in the background. Notice there are no turn lanes and the signals are on the corners, not above the intersections as they are today. The aerial photograph shows Five Points with the Texaco station at the top of the intersection, the Shell station occupying the narrow triangle property at the bottom, and the Union 76 across the street at the corner of Redwood Avenue. (Both, Reg McGovern.)

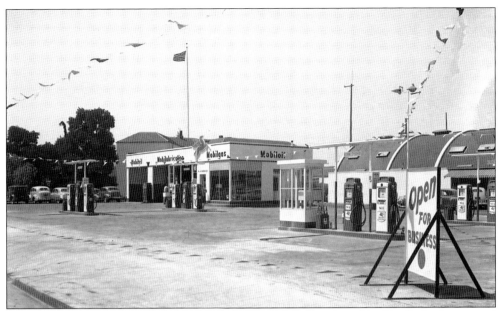

DOWNTOWN REDWOOD CITY. Howard E. "Gene" Bourquin and Eroldo "Rod" Gorlin opened R&R Service, a Mobil gas station, in 1945 at Main Street and Middlefield Road. The station is seen shortly after its grand reopening on August 16, 1951, following an extensive refresh. The remodeled station featured 11 new Gilbarco pumps. The station served customers until 1984, when it was cleared to make way for the City Center Plaza redevelopment. (Reg McGovern.)

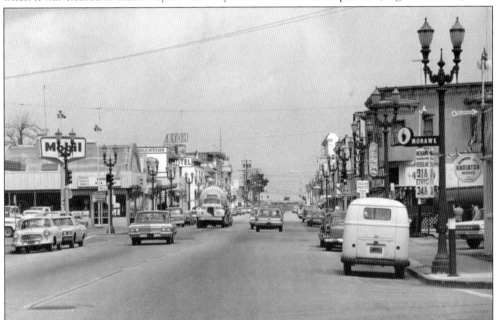

REDWOOD CITY, MID-1960S. Looking north on Main Street toward Middlefield Road in the mid-1960s shows a wide variety of cars and trucks along with the Mobil station on the west side of the street, Griffin's Mohawk Service at 1001 Main Street, and the adjoining Redwood City Radiator Works on the east side. The property where Griffin's was located is now a triangular parcel bordered by Main, Middlefield, and Maple Streets. (LHR-RWCPL.)

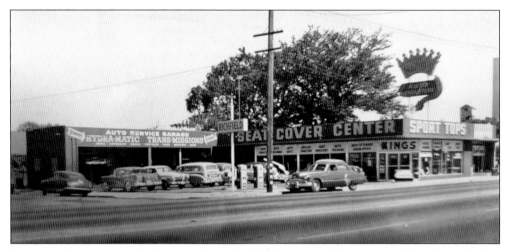

REDWOOD CITY, ALONG EL CAMINO REAL. Richfield was a widely recognized brand in the Bay Area with its distinctive eagle logo. Kings Seat Covers at El Camino Real and Diller Street was the place for auto upholstery for years. The adjacent Auto Service Garage worked on all types of transmissions and also sold Richfield gas from two curbside pumps. As a bonus, cars being serviced could leave with a full tank. On Woodside Road at Hudson Street was Ted and Don's Richfield Service station. This property is still a gas station but now sells Arco products. In the new millennium, the Kings Seat Covers block was redeveloped into the eight-story, 350-unit luxury Highwater Apartments. (Above, Reg McGovern; below, authors' collection.)

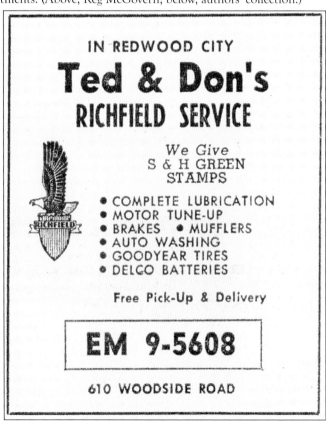

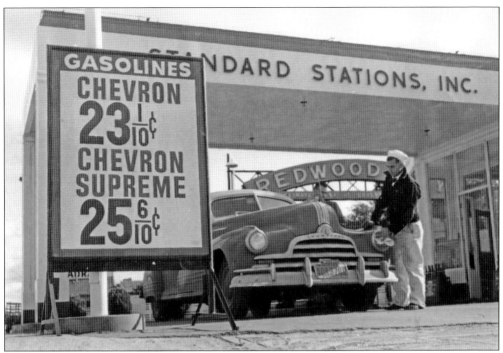

GAS WARS IN REDWOOD CITY. In the late 1940s, corporate gas stations began a price war to combat the incursion of lower-priced self-service and independent operators. Customers were used to seeing prices ending in nine-tenths of a cent, so to attract attention prices were lowered by four- to nine-tenths of a cent. This Standard station was located on the corner of El Camino Real and Claremont Street, just inside the Redwood City border. Notice the "Climate Best by Government Test" Redwood City sign to the rear. By the mid- to late 1960s, the station had been remodeled and was offering Blue Chip Stamps. The excess of Chrysler cars in the photograph below are all associated with Ely Motor Company at 346 El Camino Real. (Both, Reg McGovern.)

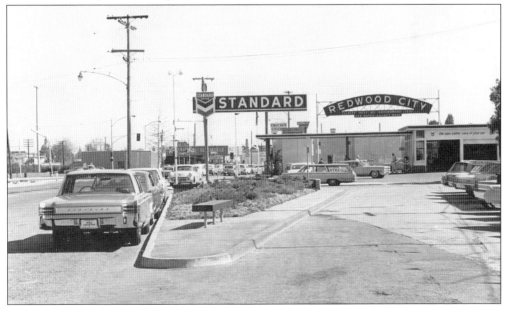

GAS CRISIS. The 1973 Arab-Israeli War (October 1973 to March 1974) resulted in an oil embargo to nations that supported Israel. US oil imports from participating Organization of Arab Petroleum Exporting Countries (OAPEC) nations were curtailed, and OAPEC began a series of production cuts that altered the world price of oil. These cuts quadrupled the price of oil from $2.90 per barrel to $11.65 per barrel in January 1974. The resulting petroleum shortage saw a form of rationing where gas was sold to consumers on odd or even days, based upon a car's license plate numbers. This aerial photograph shows more than 40 cars waiting on Hudson Street for the pumps at the Arco station at 610 Woodside Road. (LHR-RWCPL.)

PRICE SPIKE. The 1979 oil crisis saw shortages of gasoline and diesel fuel peak in May, June, and July, which led to panic buying and long lines at the pump. The first oil price spike in 1973 sent consumers rushing to trade in their 1960s vintage V8 gas guzzlers and replace them with smaller, more economical four-cylinder cars. This photograph shows stations on the corner of Veterans Boulevard and Whipple Avenue with Hondas and Volkswagens approaching the pumps. (LHR-RWCPL.)

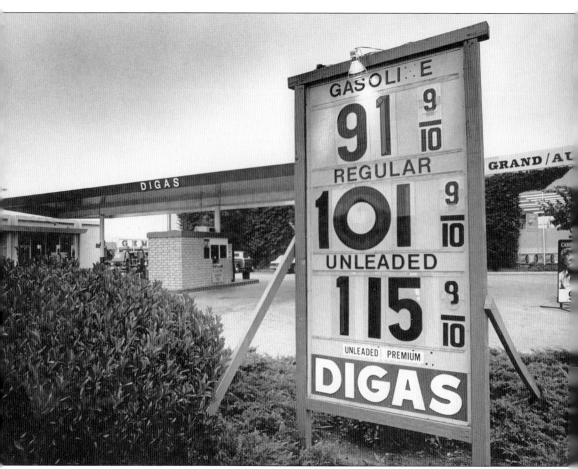

DISCOUNT GAS IN REDWOOD CITY. Digas was a discount, self-service station associated with the Gemco Store at 2485 El Camino Real, south of Woodside Road, and shared the parking lot with Grand Auto Parts. Digas stations could be found at most Gemco stores. Gemco was a subsidiary of Lucky Stores, operating from 1959 to 1986. In an effort to avoid a hostile takeover, Lucky liquidated its Gemco operations and sold a number of store leases to Target, enabling the discounter to gain a foothold on the West Coast. The Digas stations were usually removed during rebranding for Target stores. (LHR-RWCPL.)

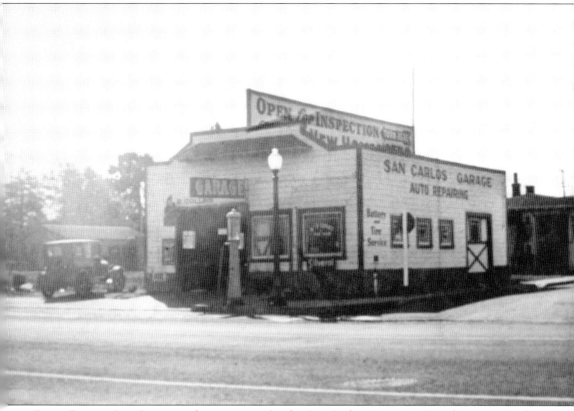

Early Days in San Carlos. Advertisements for the San Carlos Garage at 500 El Camino Real touted that shop manager H.W. Mallory personally guaranteed every job. The company also offered "gas, oils, and greases" and repaired all makes of cars. Considering that by the early 1920s, more than half of all automobiles on the road were Ford Model Ts, there was probably a good chance they had parts in stock to repair most cars that came down El Camino Real. Notice how close the visible gas pump is to the curb. It is interesting that the corner of El Camino Real and Holly Street has been a service station of one type or another for more than 100 years. Today, 500 El Camino Real is home to a Shell station and Circle K mini market. (SCMH.)

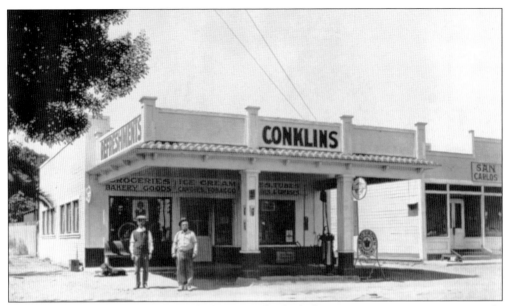

STOP AND SHOP IN SAN CARLOS. Today's drivers might think the mini-mart is a recent invention. In fact, the combination store and gas station dates back over 100 years. As seen in this 1915 image, Conklins store on El Camino Real dispensed Red Crown gasoline and sold automobile parts as well as groceries. The gas pump seen near the right pillar is likely an early Bowser or Gilbert and Barker hand crank model. (San Carlos Chamber of Commerce.)

EARLY SAN CARLOS SHELL STATION. A. Gottfriedsen owned the Shell gas station at the corner of El Camino Real and Eaton Avenue, just one block away from the Redwood City border. In May 1935, Gottfriedsen was selling various grades of engine oil (SAE 30, 40, or 50) for $1.25 for five gallons; however, customers had to bring their own containers. The station has three visible pumps out front, a maintenance rack to the right, and the attendant can be seen inside the station awaiting another customer. (LHR-RWCPL.)

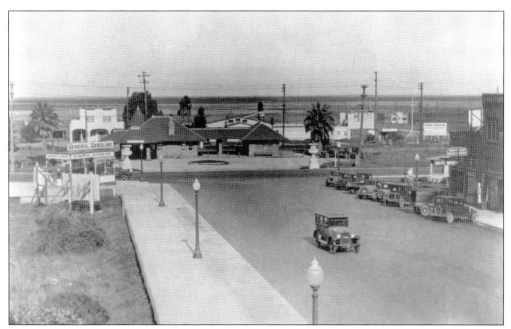

DOWNTOWN SAN CARLOS. This c. 1925 image shows an overview of El Camino Real and San Carlos Avenue. The Southern Pacific train station dominates the east side of the boulevard with the McCue hotel in the background to the left. Notice that the property stretching to the bay is undeveloped at this point. Below, this General gasoline station, also known as "Sharkey's Station," named for the owner Newell Francis Sharkey, opened around 1925 on the corner of El Camino Real and San Carlos Avenue. In this view behind the station and across the street, stood the tract office of Fred H. Drake, an early developer of San Carlos. In 1929, the tract office was torn down, and Drake erected the signature Drake Building, which still stands today. (Both, SCMH.)

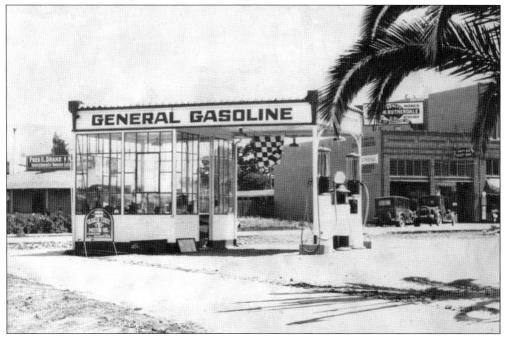

109

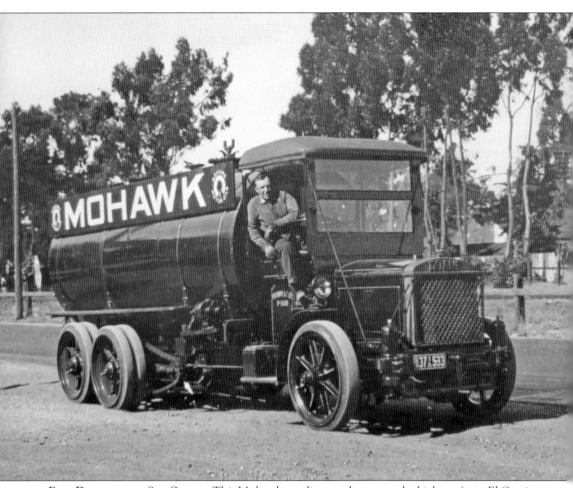

FUEL DELIVERIES TO SAN CARLOS. This Mohawk gasoline truck seen on the highway (now El Camino Real, Highway 82) appears to be brand new. It is a 1925 Doane tanker about to make deliveries to the various Mohawk stations across the San Francisco Peninsula. Doane Motor Trucks, a West Coast firm, manufactured products at 428 Third Street in San Francisco beginning in 1916. This tanker, likely introduced in 1923, was a six-wheel vehicle powered by a 36-horsepower Waukesha engine with a capacity of over 10 tons. It was chain-driven and sported solid rubber tires. (SCMH.)

STATION PROPRIETOR. Newell F. Sharkey was a longtime San Carlos merchant who owned the Mobilgas station and towing business located on El Camino Real at San Carlos Avenue. This 1941 Dodge sedan has come to an abrupt halt after striking another vehicle on El Camino Real just north of San Carlos Avenue. Sharkey's gas station and towing service, located across the street, made quick work of clearing the wreckage from the boulevard. The unusual tow "car" was a modified 1925 Lincoln sedan fitted with a hoist. In the background is one of several Mobilgas stations in San Carlos. Below, Sharkey is seen years later at the station with his 1940s Dodge tow truck. In the 1950s, he sold the gas station and opened a photography business on Laurel Street. He also served on the city council and as mayor. (Both, SCMH.)

SAN CARLOS FLYING A. San Carlos's Associated service station once occupied the corner of Cherry Street and El Camino Real. The building was constructed in the Streamline Moderne architectural style and featured curving forms as seen in the gas pump canopy and "wedding cake" roof topper. The three National A-38 pumps were also styled to complement the station's architecture. The National pumps were covered in light green porcelain with curved ad glass. (SCMH.)

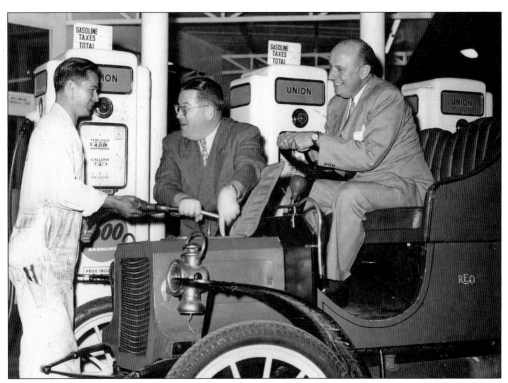

UNIQUE VISITOR. On October 24, 1949, famous bandleader and San Carlos resident Ted Weems paid a visit to Nielsen's Union 76 gas station on El Camino Real in his 1905 REO. The attendant feigns confusion as to where to pump the gas into this vintage horseless carriage while Weems (right) and newspaper columnist Jack McDowell (center) smile approvingly. Weems gained notoriety through appearances on the Jack Benny and *Fibber McGee & Molly* radio programs. (SCMH.)

RE-REFINED. Morlube was the trade name for re-refined motor oil sold by the Bayside Oil Co. The company was founded by Rex Helmer in 1932 at 977 Brandsten Road and refined used crankcase oil. This re-refined oil was then sold to farmers, loggers, railroads, or industrial plants. It took 10 gallons of used oil to produce six gallons of re-refined oil. Bayside Oil Co. was producing 3,500 gallons of re-refined oil per day in 1967 and had storage for 250,000 gallons of used oil and 60,000 gallons of finished product. Longtime San Carlos residents said that when the wind direction changed, one could smell the oil all over town. (Authors' collection.)

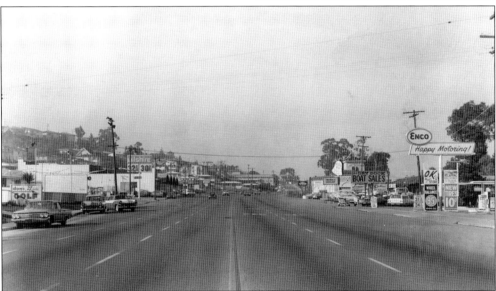

ALONG EL CAMINO REAL. In the city of San Carlos, as late as 1975, there were more than 20 gas stations within the city limits; an astonishing number for such a small town. In this 1964 photograph along El Camino Real north of Holly Street, three stations can be seen. On the right is an Enco station at 259 El Camino (where a Taco Bell restaurant now stands). Across the street is a Wilshire station, today the home of a McDonald's restaurant. And, barely visible in the distance, is a Union 76 station at the corner of Hull Drive. (SCMH.)

RIGHT OFF THE FREEWAY. San Carlos Avenue is, essentially, the gateway to the city, as it leads to the business district on Laurel Street and continues into the residential area west of downtown. The northwest corner of San Carlos Avenue and El Camino Real has been a gas station since before the city was incorporated (see page 109). The early-1950s view of Al Mitchell's Mobil service station above shows the station when owned by Alford W. Mitchell and Percy Minch and equipped with Martin and Schwartz model 80 "script top" pumps. Mitchell and Minch sold the station to Montford Robinson Jr. in December 1955. Below is the Mobil station at 906 Holly Street at Industrial Road on its opening day. Note the peaked roof canopy covering the pumps and the Pepsi machine under the covered walkway at right. (Both, SCMH.)

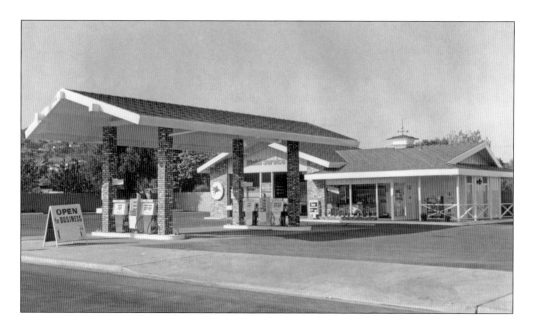

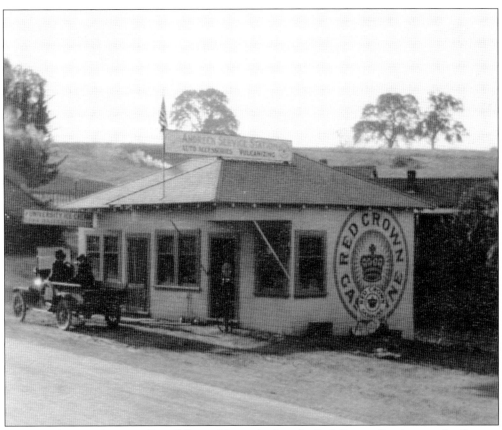

WOODSIDE'S FIRST STATION. Zaepffel's—and later, Andreen's—Red Crown Service was the first gas station in town. It was located on Woodside Road across from Whiskey Hill Road. In this 1919 image, two customers are seen at Andreen's aboard their early pickup truck, possibly a Ford Model T. The station offered auto accessories, vulcanizing (a process for hardening tires), groceries, and ice cream. The primitive hand crank gas pump can be seen at the curb in front of the station's office door. (WCM.)

WOODSIDE RICHFIELD. This Richfield gas station was once located on Woodside Road across from Whiskey Hill Road. Previous to the Richfield brand, the station dispensed Standard Oil and Red Crown gasoline. In this early-1930s photograph, a single pump is seen in front of the small grocery store. To the left is the Woodside Ice Depot, where ice was made and delivered daily by "Tony the Iceman" Zaepffel in his Ford Model A van. (WCM.)

115

STANDARD OIL STATION. The Standard Oil Big Oak Service Station was once located at 3340 Woodside Road, correspondingly next to a giant oak tree. The station boasted three hand-operated, visible gasoline pumps; RPM oil for 25¢ a quart; and free crankcase service. The building was adjacent to the Little Grocery Store, which was later converted into a restaurant. The gas station was eventually demolished in favor of a parking lot for the Little Store. (WCM.)

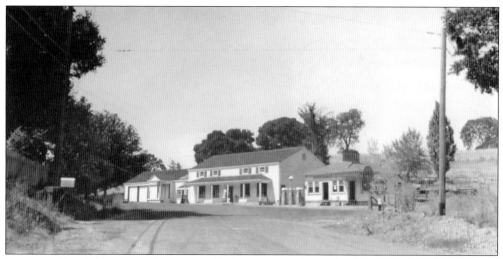

SHELL FOR SALE. This quaint, three-pump Shell station was located at the intersection of Woodside and Whiskey Hill Roads. The Shell brand replaced a Red Crown station, which was the first gas station in Woodside. Next to the station is Holt's Country Store, a full-service grocery with home delivery. In the 1940s, the store added a post office and ice delivery business. The old Holt's store building remains today as an attractive Compass real estate office. (WCM.)

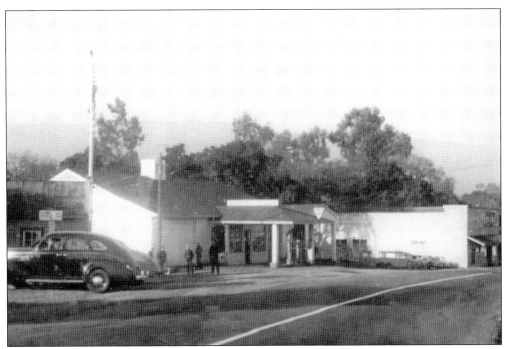

CHANGING BRANDS. Boyd Machett started as a distributor for Tidewater Oil Company operating a Seaside Oil gas station in the 2900 block of Woodside Road. Later, the station transitioned to Union 76 products and increased its repair rack space. The photograph below was taken in the mid-1960s with a 1957 Cadillac Coupe DeVille in the shop with its hood up. Note that the gas dispensers have been updated to a variety of Wayne pumps. (Both, WCM.)

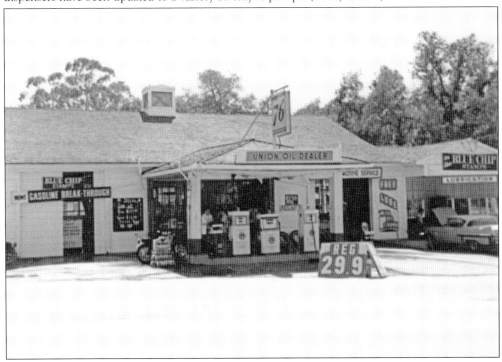

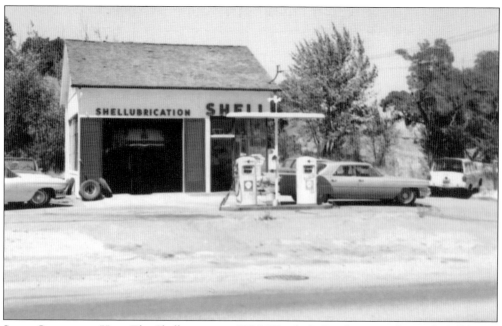

SHELL GAS ON THE HILL. The Shell station at 2920 Woodside Road is one of several Shell-brand stations built over the last century at this location. The first Shell station was really a barn and blacksmith shop founded in 1890. That building was remodeled into a Richfield station and years later modified again into a Shell station. That station was rebuilt as shown in this 1967 photograph but later torn down in the 1970s to widen Woodside Road. (WCM.)

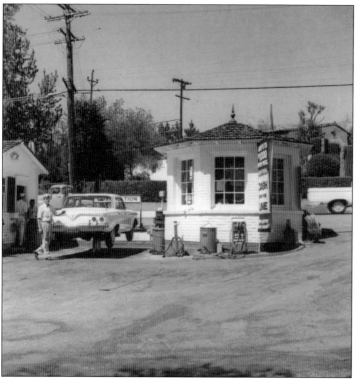

STANDARD OIL STATION. A most unusual hexagon-shaped station once stood in the middle of Woodside Road at Mountain Home Road, just east of Robert's Market in Woodside. Originally a small stucco and tile-roofed Shell building, it later became a Standard Oil station with a shake roof and adjacent office and restrooms. In this 1960s view, an attendant is busy servicing a 1961 Chevrolet on the outdoor grease rack, an unusual sight even in sunny California. The station was later demolished in order to widen Woodside Road. (WCM.)

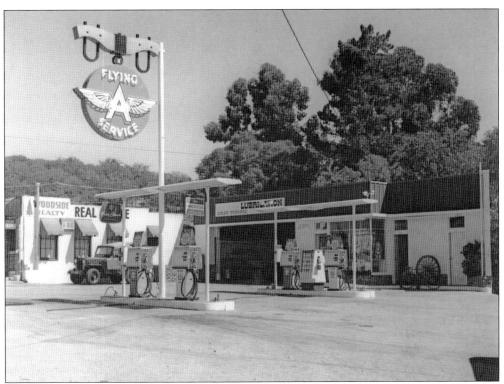

WOODSIDE FLYING A. This Associated station was once among a handful of gas stations in the town of Woodside. Located at 2989 Woodside Road in the heart of the village, this service station was a nod to the area's western roots with its unusual oxbow Flying A sign. Business appears light in this late-1950s photograph despite the 31.9¢ price of regular gasoline and offers of Blue Chip Stamps with every purchase. Seen next to the gas station is the old Woodside firehouse, currently in use in 2025 as the Firehouse Bistro Restaurant. (Both, WCM.)

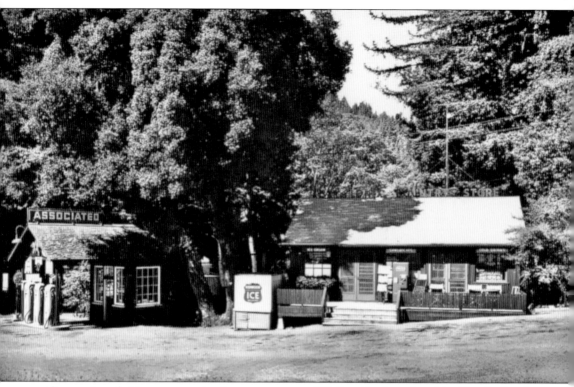

GAS AT ALICE'S RESTAURANT. At the convergence of Skyline Boulevard and La Honda Road in unincorporated San Mateo County sits a peninsula landmark, Alice's Restaurant, known for its good food and friendly atmosphere. Once called the Sky Londa Country Store, this structure and the adjacent Flying A gas station were the first two commercial buildings constructed in Sky Londa in the 1920s. The station has served customers for over 90 years under several petroleum banners, including Associated, as seen here in the 1940s, and later Chevron. Today's Alice's Gas Station operates independently and is still supplying gasoline to motorists nine decades later. (Curtis Parisi collection.)

Four

GONE BUT
NOT FORGOTTEN
CHANGING TIMES,
CHANGING TECHNOLOGY

As the automotive world marks more than 100 years since widespread adoption of the motorcar, times and technology have seen its share of changes. The proliferation of gas stations in the early to mid-20th century was driven by society's adoption of cars and trucks, the postwar availability of cars for a prosperous buying public, improvements in passenger comforts, and occupant safety changes in the 1960s and 1970s.

Following World War II, population expansion to the suburbs saw the automobile give people more independence, resulting in less use of public transportation. The lower photograph on page 10 shows a streetcar passing a new car dealership in 1948—an image that speaks volumes to the coming changes in how Americans moved about the cities and suburbs. With the shift from public transportation to private automobiles came the need for service stations that would provide the myriad of services needed by motorists—everything from fuel and consumables such as batteries, tires, and windshield wipers to tune-ups and major repairs.

One of the amazing aspects of the proliferation of gas stations is the number of locations that have been petroleum retailers for more than a century. The owners and the gasoline brands have changed, often numerous times, yet the property remains a service station.

Climate change and the impact of burning fossil fuels to power cars, trucks, and big rigs has weighed on the collective consciousness of motorists for decades. Technology changes in battery storage life, charging infrastructure, and electronics, coupled with massive investments from automakers and the disruption to that business model by Tesla and other electric carmakers, have all combined to make electric cars a reliable reality. As electric car prices come down, wider adoption by the public and mandated adoption by the states will have a tremendous impact on the retail gasoline industry.

The 1948 photograph of the DeSoto dealership and the streetcar is a thought-provoking comparison with the last photograph of the book—a battery-electric Tesla at the pump island of a once flourishing Shell station. Will the wide adoption of electric vehicles spell the eventual end to the gas station?

BUILDING A STATION. Before San Carlos became a city, the corner of El Camino Real and Arroyo Avenue was home to the Babylon Roadhouse and Dance Hall. The restaurant was torn down after World War II, and in August 1946, work began to fill the property with the George Nielsen's Union 76 station. Notice Laurel Street, behind the gas station property, is devoid of buildings, although the street has been paved. (Jeff Nielsen.)

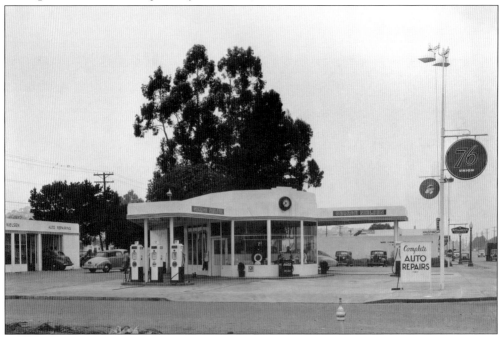

READY TO SERVE. When the Nielsen's new station opened at 888 El Camino Real, the building's Streamline Moderne architecture formed an airplane of sorts where the island canopies made the wings. The station featured Wayne 70 computing pumps and three service bays. Notice the Coca-Cola cooler in front of the office and the round "Minute Man Service" sign showcasing the full, fast service offered at the time. (Jeff Nielsen.)

FULL SERVICE IN ACTION. Minute Man—or in this case, "Minute Staff"—service is provided to a motorist in a restored 1951 Ford convertible. Attendant Jessica Kunz washes the windows while station owner Jeff Nielsen checks the tire pressure. The drive to reduce labor costs after the gas crisis in the 1970s and 1980s saw stations transition away from full-service to self-service pumps. The Nielsen's station was the last of the full-service stations on the mid-peninsula. (Darryl Lindsay.)

THE END OF AN ERA. The Nielsen station pumped its last gallon on February 14, 2022, after 76 years in business. Chris and Jeff Nielsen, grandsons of station founder George Nielsen, began working at the business straight out of high school, becoming master mechanics. The business was a San Carlos institution, and many in town were sad to see the end of an era. Eventually, the property will become a multistory, mixed-use development with retail on the ground floor and residences above. (Bruce Cumming.)

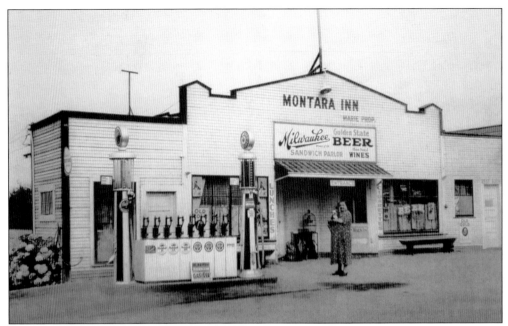

MONTARA, THEN AND NOW. The Montara Inn was built in the 1920s by Nels and Marie Kullander at 1361 Main Street near Kent's Garage and Store in what was then Farallone City. In the beginning, the building was simply an inn. Over the years, with the construction of the Ocean Shore Highway, the Kullanders added a grocery, a gas station, and a restaurant and bar. This early-1930s image shows Marie and one of the many English bulldogs she raised and sold. Also shown are two Red Crown visible gasoline pumps and a host of oil dispensers, known as "lubesters," in this small but attractive curbside station. Although the building has had a number of changes to convert it into a residence, the bones of the former inn can still be seen to this day. (Above, Josephine Ruschmeyer and Suzanne Mau; below, Nicholas A. Veronico.)

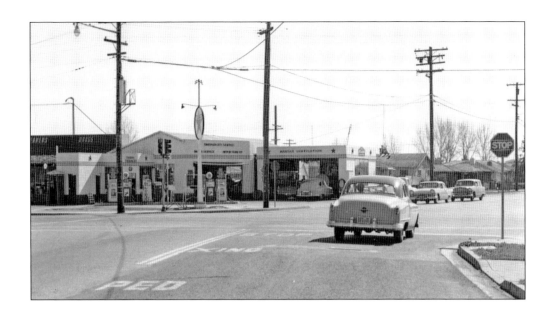

GONE INDEPENDENT. Ted's Emerald City Texaco station was located in Redwood City on the corner of Jefferson Avenue and Alameda De Las Pulgas. Though temporarily devoid of gasoline customers, the 1957 image above shows that repairs are in progress in the service bay on a 1949 Nash and 1957 Plymouth station wagon. Other cars passing by this quaint neighborhood station include a 1952 Oldsmobile 88, a 1957 Ford, and a 1955 Chevrolet. This station operates today as Jefferson Gas and Shop after more than 70 years in business dispensing gas. It is ironic that the building remains largely unchanged, as does the adjacent Jefferson Plaza strip mall. (Above, LHR-RWCPL; below, Nicholas A. Veronico.)

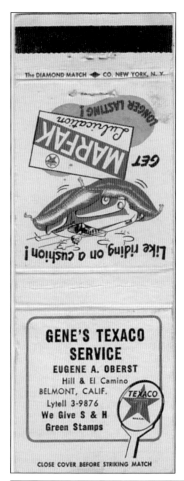

BELMONT TEXACO. Eugene A. Oberst owned and operated the Texaco station on the corner of Hill Drive and El Camino Real from the late 1950s into the 1970s. When purchasing gas, motorists received S&H Green Stamps, and the station also gave out matchbooks advertising the stations' services. The station featured a single bay with two lifts where Oberst did a brisk business in oil changes and other minor repairs. The station sat vacant for years and was finally demolished in March 2024. (Left, BHS; below, Bruce Cumming.)

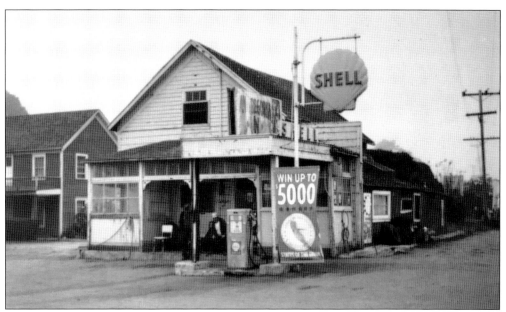

SAN GREGORIO. Eleven miles south of Half Moon Bay is the tiny village of San Gregorio (population 150). In addition to its famous general store built in 1889, the town is home to the once-popular San Gregorio House, stage stop, and hotel. As early as 1850, prominent San Franciscans traveled to the hotel to hunt, fish, and swim in the ocean. Next to the hotel was the town's only gas station, a primitive one-pump affair. As late as 1969, this Shell station was still active. Though the hotel and gas station have long since closed, the buildings remain, a monument to the past. Today, the building sits quietly amidst the coastal fog and, in an ironic omen to the future of gas stations, shelters a Tesla battery-powered automobile. (Above, Curtis Parisi collection; below, Bruce Cumming.)

Discover Thousands of Local History Books
Featuring Millions of Vintage Images

Arcadia Publishing, the leading local history publisher in the United States, is committed to making history accessible and meaningful through publishing books that celebrate and preserve the heritage of America's people and places.

Find more books like this at
www.arcadiapublishing.com

Search for your hometown history, your old stomping grounds, and even your favorite sports team.

Consistent with our mission to preserve history on a local level, this book was printed in South Carolina on American-made paper and manufactured entirely in the United States. Products carrying the accredited Forest Stewardship Council (FSC) label are printed on 100 percent FSC-certified paper.